FRANCIS FRITH'S

WELLS

PHOTOGRAPHIC MEMORIES

MARIA JEPPS was born in Hampshire and educated in London. A linguist by first profession, she has worked as an interpreter, a translator, and a teacher in the Wells area for over thirty years. She has developed a great affection for the West Country, which has led her to study its history and customs. She has also trained as a tourist guide, which now enables her to pass on her knowledge and enthusiasm for the West Country to the general public. She is a Member of the Institute of Linguists, a Member of the Guild of Registered Tourist Guides and a Member of the Institute of Tourist Guiding.

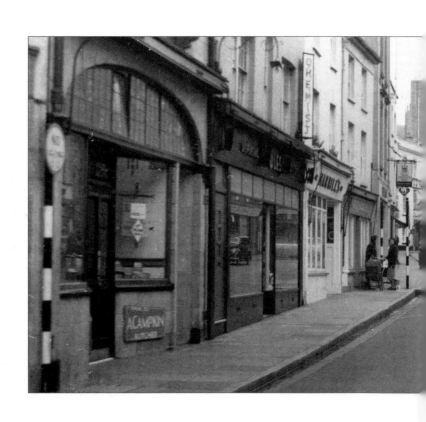

FRANCIS FRITH'S
PHOTOGRAPHIC MEMORIES

WELLS

PHOTOGRAPHIC MEMORIES

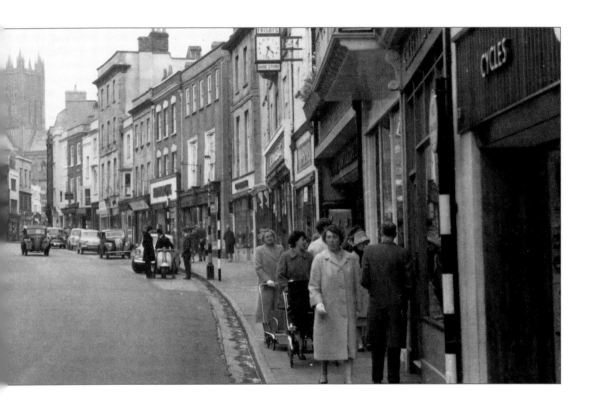

MARIA JEPPS

FRITH Book Co

First published in the United Kingdom in 2003 by
Frith Book Company Ltd

Paperback Edition 2003
ISBN 1-85937-316-x

British Library Cataloguing in Publication Data

Francis Frith's Wells Photographic Memories
Maria Jepps

Frith Book Company Ltd
Frith's Barn, Teffont,
Salisbury, Wiltshire SP3 5QP
Tel: +44 (0) 1722 716 376
Email: info@francisfrith.co.uk
www.francisfrith.co.uk

Printed and bound in Great Britain

Front Cover: Wells, Market Place 1923 73991

AS WITH ANY HISTORICAL DATABASE THE FRITH ARCHIVE IS CONSTANTLY
BEING CORRECTED AND IMPROVED AND THE PUBLISHERS WOULD
WELCOME INFORMATION ON OMISSIONS OR INACCURACIES

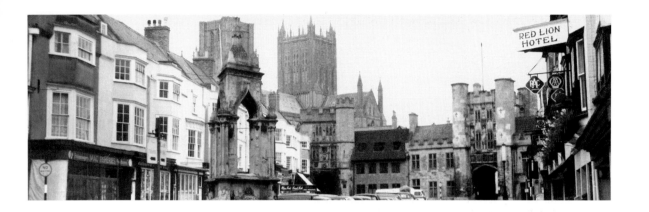

CONTENTS

FRANCIS FRITH
VICTORIAN PIONEER

FRANCIS FRITH, founder of the world-famous photographic archive, was a complex and multi-talented man. A devout Quaker and a highly successful Victorian businessman, he was philosophic by nature and pioneering in outlook.

By 1855 he had already established a wholesale grocery business in Liverpool, and sold it for the astonishing sum of £200,000, which is the equivalent today of over £15,000,000. Now a multi-millionaire, he was able to indulge his passion for travel. As a child he had pored over travel books written by early explorers, and his fancy and imagination had been stirred by family holidays to the sublime mountain regions of Wales and Scotland. 'What a land of spirit-stirring and enriching scenes and places!' he had written. He was to return to these scenes of grandeur in later years to 'recapture the thousands of vivid and tender memories', but with a different purpose. Now in his thirties, and captivated by the new science of photography, Frith set out on a series of pioneering journeys up the Nile and to the

Near East that occupied him from 1856 until 1860.

INTRIGUE AND EXPLORATION

These far-flung journeys were packed with intrigue and adventure. In his life story, written when he was sixty-three, Frith tells of being held captive by bandits, and of fighting 'an awful midnight battle to the very point of surrender with a deadly pack of hungry, wild dogs'. Wearing flowing Arab costume, Frith arrived at Akaba by camel seventy years before Lawrence of Arabia, where he encountered 'desert princes and rival sheikhs, blazing with jewel-hilted swords'.

He was the first photographer to venture beyond the sixth cataract of the Nile. Africa was still the mysterious 'Dark Continent', and Stanley and Livingstone's historic meeting was a decade into the future. The conditions for picture taking confound belief. He laboured for hours in his wicker dark-room in the sweltering heat of the desert, while the volatile chemicals fizzed dangerously in their trays. Back in London he exhibited his photographs and was 'rapturously cheered' by members of the Royal Society. His reputation as a photographer was made overnight.

VENTURE OF A LIFE-TIME

Characteristically, Frith quickly spotted the opportunity to create a new business as a specialist publisher of photographs. He lived in an era of immense and sometimes violent change.

For the poor in the early part of Victoria's reign work was exhausting and the hours long, and people had precious little free time to enjoy themselves. Most had no transport other than a cart or gig at their disposal, and rarely travelled far beyond the boundaries of their own town or village. However, by the 1870s the railways had threaded their way across the country, and Bank Holidays and half-day Saturdays had been made obligatory by Act of Parliament. All of a sudden the working man and his family were able to enjoy days out and see a little more of the world.

With typical business acumen, Francis Frith foresaw that these new tourists would enjoy having souvenirs to commemorate their days out. In 1860 he married Mary Ann Rosling and set out on a new career: his aim was to photograph every city, town and village in Britain. For the next thirty years he travelled the country by train and by pony and trap, producing fine photographs of seaside resorts and beauty spots that were keenly bought by millions of Victorians. These prints were painstakingly pasted into family albums and pored over during the dark nights of winter, rekindling precious memories of summer excursions.

THE RISE OF FRITH & CO

Frith's studio was soon supplying retail shops all over the country. To meet the demand he gath-ered about him a small team of photographers, and published the work of independent artist-photographers of the calibre of Roger Fenton and Francis Bedford. In order to gain some understanding of the scale of Frith's business one only has to look at the catalogue issued by Frith & Co in 1886: it runs to some 670 pages, listing not only many thousands of views of the British Isles but also many photographs of most European countries, and China, Japan, the USA and Canada - note the sample page shown here from the hand-written Frith & Co ledgers record-ing the pictures. By 1890 Frith had created the greatest specialist photographic publishing company in the world, with over 2,000 sales out-lets - more than the combined number that Boots and WH Smith have today! The picture on the next page shows the Frith & Co display board at Ingleton in the Yorkshire Dales. Beautifully constructed with mahogany frame and gilt inserts, it could display up to a dozen local scenes.

POSTCARD BONANZA

The ever-popular holiday postcard we know today took many years to develop. In 1870 the Post Office issued the first plain cards, with a pre-printed stamp on one face. In 1894 they allowed other publishers' cards to be sent through the mail with an attached adhesive half-penny stamp. Demand grew rapidly, and in 1895 a new size of postcard was permitted called the court card, but there was little room for illustra-tion. In 1899, a year after Frith's death, a new card measuring 5.5 x 3.5 inches became the standard format, but it was not until 1902 that the divided back came into being, so that the address and message could be on one face and a full-size illustration on the other. Frith & Co were in the vanguard of postcard development: Frith's sons Eustace and Cyril continued their father's monumental task, expanding the number of views offered to the public and recording more

5	•	*[illegible] College, view from [illegible]*			+
6	•	*St Catherine's College*	+		
7	•	*Senate House & Library*	+		
8	•			+	
3 0	•	*Gerrard Hostel Bridge*	+	+	+ + +
		Geological Museum		+	
1	•	*Addenbrookes Hospital*		+	
2	•	*St Marys Church*		+	
3	•	*Fitzwilliam Museum, Pitt Press &c*		+	
4	•			+	
5	*Buxton, The Crescent*				+
6	•	*The Colonnade*			+
7	•	*Public Gardens*			+
8	•				+
9	*Haddon Hall, View from the Terrace*				+
4 0	*Millers Dale*				+

and more places in Britain, as the coasts and countryside were opened up to mass travel.

Francis Frith had died in 1898 at his villa in Cannes, his great project still growing. The archive he created continued in business for another seventy years. By 1970 it contained over a third of a million pictures showing 7,000 British towns and villages.

FRANCIS FRITH'S LEGACY

Frith's legacy to us today is of immense significance and value, for the magnificent archive of evocative photographs he created provides a unique record of change in the cities, towns and villages throughout Britain over a century and more. Frith and his fellow studio photographers revisited locations many times down the years to update their views, compiling for us an enthralling and colourful pageant of British life and character.

We are fortunate that Frith was dedicated to recording the minutiae of everyday life. For it is this sheer wealth of visual data, the painstaking chronicle of changes in dress, transport, street layouts, buildings, housing, engineering and landscape that captivates us so much today. His remarkable images offer us a powerful link with the past and with the lives of our ancestors.

THE VALUE OF THE ARCHIVE TODAY

Computers have now made it possible for Frith's many thousands of images to be accessed almost instantly. Frith's images are increasingly used as visual resources, by social historians, by researchers into genealogy and ancestry, by architects and town planners, and by teachers involved in local history projects.

In addition, the archive offers every one of us an opportunity to examine the places where we and our families have lived and worked down the years. Highly successful in Frith's own era, the archive is now, a century and more on, entering a new phase of popularity. Historians consider the Francis Frith Collection to be of prime national importance. It is the only archive of its kind remaining in private ownership. Francis Frith's archive is now housed in an historic timber barn in the beautiful village of Teffont in Wiltshire. Its founder would not recognize the archive office as it is today. In place of the many thousands of dusty boxes containing glass plate negatives and an all-pervading odour of photographic chemicals, there are now ranks of computer screens. He would be amazed to watch his images travelling round the world at unimaginable speeds through internet lines.

The archive's future is both bright and exciting. Francis Frith, with his unshakeable belief in making photographs available to the greatest number of people, would undoubtedly approve of what is being done today with his lifetime's work. His photographs depicting our shared past are now bringing pleasure and enlightenment to millions around the world a century and more after his death.

THE CITY OF WELLS

AN INTRODUCTION

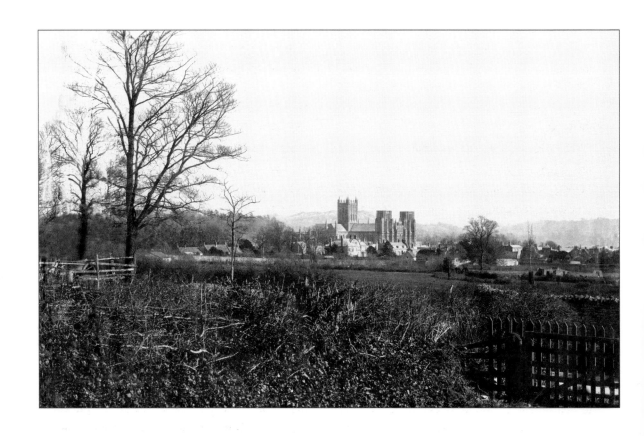

WELLS, *The Cathedral 1890* 23864

WHERE the main road from Bath spills over the Mendip Hills, a gap in the trees allows a view of the 'summer land' of Somerset. Glastonbury Tor spears the morning mist with its medieval tower, and the view extends to the Quantocks beyond. The fields and hedgerows are criss-crossed by the rhynes of the Somerset levels, channels of water chequering the landscape like the description in 'Alice's Adventures through the Looking-Glass' by Lewis Carroll: " ... and a most curious country it was. There were a number of tiny little brooks running straight across it from side to side, and the ground between was divided up into squares by a number of little green hedges, that reached from brook to brook. 'I declare, it's marked out just like a large chessboard !' Alice declared at last."

The road dips steeply into the city of Wells, the smallest city in England, sheltered by the Mendip hills. (The Mendips are carboniferous limestone, and are a pot-holing and caving wonderland, veined with traces of 43 minerals, including the lead which lines the Roman baths at Bath and at Pompeii in Italy). The name of the city derives from the Old English (Anglo-Saxon) word for spring.

Five springs rise behind the cathedral, four in the lake we can see in photograph No 23870, producing 18000 cubic metres of water per day. The south side of the Mendip hills from Pen Hill to Beacon Hill drain into underground streams feeding St Andrew's well, as the lake formed by these springs is called. In Roman times, a mausoleum was built west of the springs. King Ine of Wessex founded the first minster church beside the spring in about 705, and in 909 Edward, eldest son of Alfred the Great, chose Wells for Bishop Athelm's cathedral in the new diocese of Somerset. In pre-Norman times, the town already extended between the Saxon parish church at one end and the cathedral at the other (see photograph No 23865, page 17). The Saxon cathedral was built south of the present one, aligned with the Market Place and High Street. Its excavated outline is on view in the garden alongside and to the south of the present building. The present cathedral was begun in 1180; building began at the east end, and was completed at the west front by about 1330.

There is no separate record of the town in the Domesday book, or before 1160, although the estates held by the bishop are mentioned, including the manor of Wells. In 1160, the first Norman bishop, John de Villula, granted the first charter to the town, and the basic plan of the streets was in place by about 1250. In 1201 King John gave the town a royal charter, making it a free borough. By 1340, Wells had more woollen cloth merchants than Coventry and was an important market town, holding weekly markets and up to five fairs a year.

By the 14th century, Wells was the largest town in Somerset, and among the most important towns in the country. As in many other cathedral towns, the townspeople found the bishops' authority irksome (the bishops had supervised the choice of two members of Parliament since 1298), but no actual uprisings took place. Nevertheless, Bishop Ralph of Shrewsbury protected his palace and the cathedral with crenellated walls, and formed the moat in 1340. Henry IV granted the town a charter recognising it as a corporate body in 1399, so members of Parliament could be elected by the burgesses and freemen.

The Black Death caused the sheep fair to be transferred to the village of Priddy, where it remained. At the time of the plague, food and money were exchanged on a slab three miles outside the city (the site of an inn today) to prevent infection spreading out from Wells. An incomplete memorial is carved into a slab at the base of the west front of the cathedral: 'Pur lalme Johan de Puttenie priez et trez jours de' ('pray for the soul of John of Pitney and 13 days ...'). John of Putteney was a chantry priest of Crewkerne in 1345, and he died in December 1348. The sculptor too probably died of the plague before he could complete the inscription.

In the 15th century, Bishop Bekynton constructed his 'New Works': three stone gateways and twelve houses along the north side of the Market Place by the cathedral churchyard. He

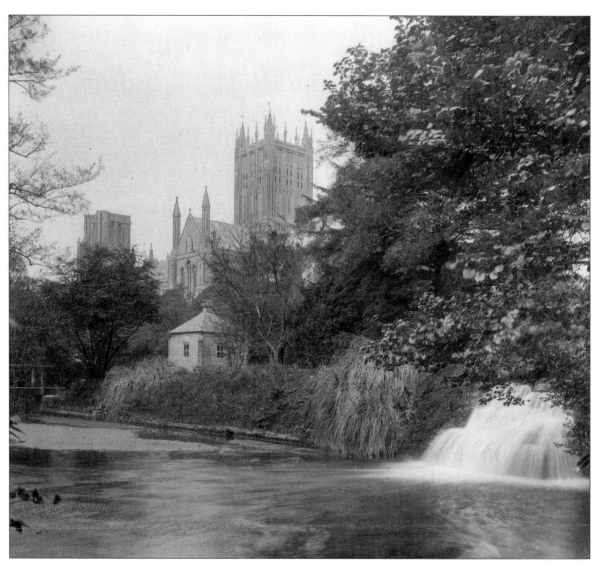

WELLS, *The Cathedral and Moat c1920* W47314

shared his water supply with the town, building a stone well house and using lead pipes to bring the water from the spring behind the cathedral to the 'New Works' and to the stone conduit which he built in the market place. During the Wars of the Roses, Margaret of Anjou, mother of Edward, Prince of Wales, passed through Wells in 1471 en route to Tewkesbury, where her Lancastrian army was defeated and the Prince killed. When Henry VII arrived in Wells on 1 October 1497 with his cavalry, he stayed overnight in the Deanery (photograph No 31341) and fined the town £314 for favouring Perkin Warbeck, the impostor who plotted against him by pretending to be the Duke of York - Henry hanged Perkin Warbeck in 1499.

In the 16th century, while Michelangelo was painting the Last Judgement on the ceiling of the Sistine Chapel, in England Henry VIII was suppressing the monasteries. The cathedral at Wells had never been a monastic foundation, so it escaped the fate of the abbey at Glastonbury, but it lost the gifts for chantry chapels and for prayers for the dead. Because of the loss of this income, Bishop Barlow (1548-54) had to sell the lead and wood from the roof of the banqueting hall in his palace (photograph No 23895) to pay for repairs to the cathedral.

In 1539 the last abbot of Glastonbury, Richard Whyting, would not surrender his abbey to the King's men. He was accused of high treason, and of having hidden from the King's men a chalice and other religious objects made of gold. (The abbot would have considered items used in the celebration of Holy Mass as sacred, not to be sold by the king for secular use). He also agreed with the Pope as regards Henry's divorce from Katherine of Aragon. The abbot was brought from the Tower of London for a semblance of a trial in the banqueting hall of the bishop's palace at Wells, and was declared guilty. (The chair in which he sat when he was accused still stands in the palace). The following day, the eighty-year-old abbot was pulled through the streets on a hurdle and up Glastonbury Tor, where he was hanged until nearly dead, and his innards drawn while he was barely alive; his head was impaled on the abbey gatehouse. The quarters of his trunk were boiled in pitch and exposed in Wells, Bath, Bridgwater and Ilchester. The abbey was destroyed. At a time when the church and its institutions were so important in everyday life, this event could hardly have passed unnoticed by the citizens of Wells.

The first legal document formally to call Wells a city appeared in July 1589: Queen Elizabeth I granted Wells a charter declaring it 'a free city and borough of itself'. The city was allowed to run a jail, two courts and six annual fairs. By the end of the 16th century, after the famines of 1586 and 1594 and the plague of 1593, the population increased as farm workers moved to the city for work and food. The Corporation and the wealthier gentlefolk invested in lodgings and care for the poor and the sick, and in providing work and a house of correction for the able and the troublesome. Relations between the cathedral and the city improved; the balance of power changed as the woollen industry lost its importance, and lead mining, silk and linen manufacture replaced it. Property was bought from the bishop and other religious institutions.

In the 17th century, there were many inns in the city where tradesmen would do their bargaining, and many people were involved in related occupations, such as legal clerks and money-

lenders. The shops and their suppliers were also thriving. The wealthier tradespeople aspired to become bourgeois gentlemen. Despite the rise of Puritanism, religious processions and various other festivities still took place in the town. Eventually, the dominance of the puritan ethic brought the traditional jollities to a close. The Civil War and the Monmouth Rebellion brought trouble: Royalists plundered the town, Parliamentarians damaged the cathedral fabric and contents along with the Bishop's Palace. Monmouth's troops followed, adding to the damage and keeping their horses in the cathedral. In 1685, the Bloody Assizes were held after the Monmouth Rebellion by Judge Jeffreys in the Exchequer building in the Market Place. In 1695 William Penn, the Quaker, preached to a crowd of thousands from a window of the Royal Oak Inn. The mayor sent an officer to arrest him, but the bishop had given him permission to preach and he was released. After the Restoration, life in Wells had changed, and cultural activities and entertainments were not to return as they were before.

In the 18th century, Wells became an Assize town, and continued to be one for fifty years. Certain local families became important: for example, the wealthy Tudways, who owned plantations in Antigua, bought a number of properties in the city and became seriously involved in local politics. One of these properties was The Cedars, designed in 1758 by Thomas Paty of Bristol; it was built on the site of the 13th-century house of the master mason of the cathedral, Adam Locke, and the site of the original cathedral grammar school in 1235. It is now the headquarters of the world-famous Wells Cathedral School.

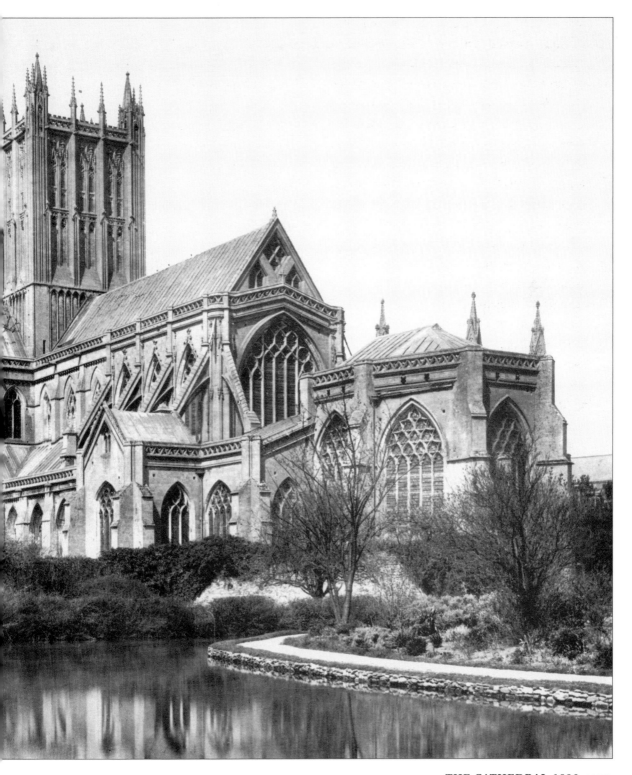

THE CATHEDRAL *1890* 23870

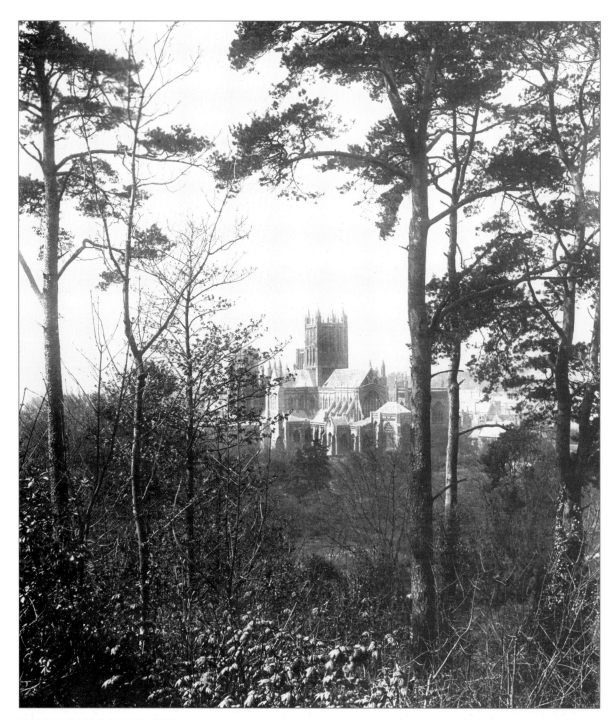

THE VIEW FROM THE TOR *1890* 23866a

Here we see Tor Woods, which now belong to the National Trust. Tor Hill quarry yields the Chilcote conglomerate stone (red Triassic sandstone) used in the construction of many buildings in the city, including parts of the Bishop's Palace. The road to Shepton Mallet passes between the trees and the cathedral. In 1207 King John allowed Bishop Jocelyn to move the road from its medieval position across Palace Fields to improve the area for hunting.

By the 19th century, Wells was a market centre with railway services, including three railway stations – but none of them were linked by rail. The railway companies were the Somerset and Dorset, the Somerset Central, and the Great Western Railway. The last line and station closed in 1960 – this was the famous Strawberry Line carrying fresh strawberries from Cheddar to London. The Corporation and the Wells Turnpike Trustees improved the roads. They also bought the bishop's mill and the adjoining property, replacing them with the Market Hall, now the post office (see photograph No W47097). Various medieval buildings, such as the Hospital of St John, were demolished to allow modern schools and hospitals to be built. As non-conformists were now allowed to practise their religion more openly, a number of churches were erected at this time.

In the 20th century, the population of the city during the First and Second World Wars was well under 5,000. The city lost 99 men in the Great War and 38 in World War II. The Tudway family's house, The Cedars, was converted into a military hospital. During the Second World War, there was a prisoner-of-war camp at Penleigh, on the outskirts of the city. (The site was later occupied by an electronics firm, first called EMI, and now known as Thales). The Italian POWs were put to work on the local farms. Long-lasting friend-

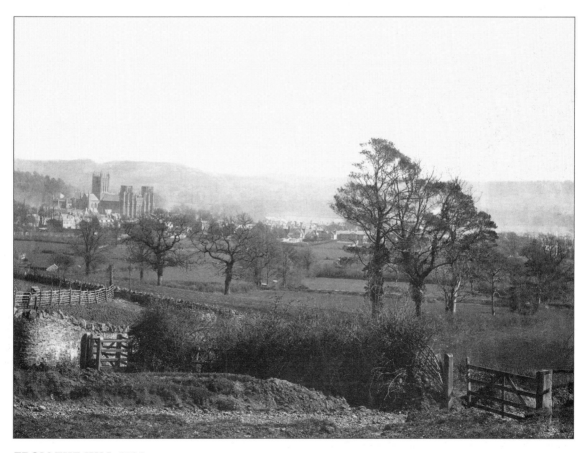

FROM THE HILL *1890* 23865

ships were made, and marriages took place with local girls. A certain Gaetano Celestra sculpted a she-wolf suckling two children, Romulus and Remus, the founders of Rome, to place on the wall along the main Bristol Road out of Wells. A number of the Italian ex-POWs returned after the war, and there is still a large Italian community in the Mendip area. The remains of defences set up for World War II still litter the landscape and have become historic in their own right, along with Neolithic and Roman remains revealed by the digging of trenches.

The Cathedral School was already in existence in the 10th century, and there are other historic schools in the area, which have developed into modern educational establishments. The Blue School opened in 1656 with 14 'poor children' in the Bubwith Almshouse chapel, financed by the bequest of Ezekiel Barkham. Nearly 350 years later it is a well-equipped community school, catering for 1401 children (21 January 2002), including the 6th form. It serves a further 1200 adult students, including the retired and elderly, who attend day and evening classes and the sports and fitness centre.

Since 1997 the path of the Wells Relief Road runs left to right in the mid-ground, of photograph 23865, from the north of Chamberlain Street to St Cuthbert's church tower and beyond. The modern Blue School complex (1965) and playing fields are situated between the gate (right) and the tower of St Cuthbert's church to the north of the relief road.

Light industry and the tourist and service industries have flourished, and computer software companies abound. Heavier industry and the larger retail outlets are on the outskirts of the city; the old mills and factories near the centre are being converted into housing developments, including a sizeable number of retirement homes.

After the closure of the railways, commercial traffic took to the road with a vengeance. The impact of heavy traffic damaged the ancient drains beneath the roads and threatened to harm the historic centre. There was conflict over where to site the Relief Road, but in 1997 it was finally built; the historic network of drains and pipes beneath the roads is being replaced, and the main thoroughfares are being 'enhanced' with more picturesque materials than the ubiquitous surface invented by Mr. John Loudon Macadam. In 1972 there were no traffic lights, no roundabouts and only one zebra crossing. In 1997 the Wells Relief Road was built, partly along the bed of the old railway line, by-passing the old city centre. It cost £13 million, and includes four kilometres of main road, 2 kilometres of side roads, one roundabout, two underpasses, three bridges, three culverts, three pelican crossings, six sets of traffic lights, badger and otter crossings, and a cycle track. Under the asphalt lies the same oolitic limestone from which the cathedral was built; it was obtained from the same quarry at Doulting, 12km away, near Shepton Mallet.

In 1641 Wells had hardly 2,000 souls, and the population increased to just 2,229 in 1801. By 1918 the population had more than doubled, and in 1971 it was 8,855. The population today is about 10,000, and considering the pleasant environment and excellent amenities, is unlikely to decrease.

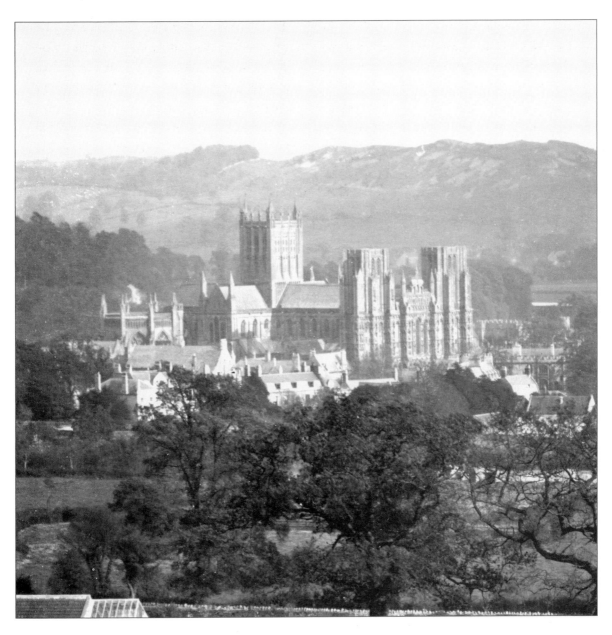

THE VIEW FROM MILTON HILL *c1900* W47306

The cathedral shelters under the Mendip Hills.

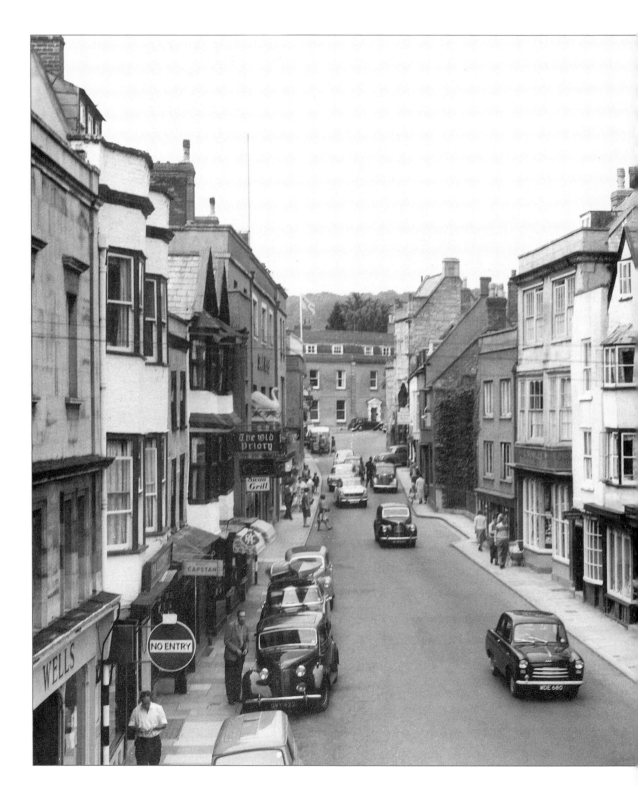

SADLER STREET

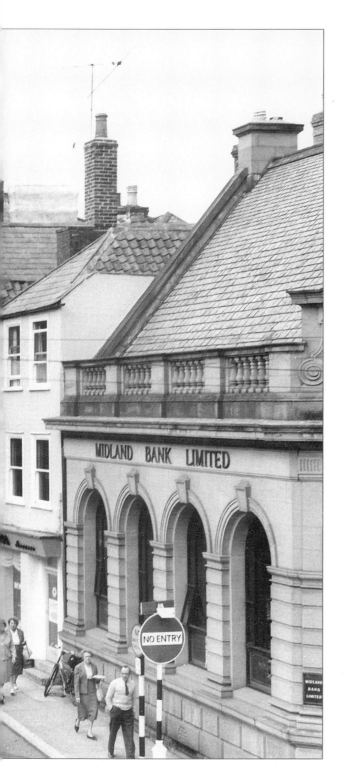

WE BEGIN the tour of the city by the Dean's Eye gate-house, the dropping-off point both for modern tour coaches and ancient stagecoaches. Until about 1970, one-way traffic passed under this gate-house into Sadler Street, the main road from London and Bath to Exeter. The Dean's Eye is also known as Browne's gate, after a cobbler who lived alongside it in 1553.

The east side of the street was developed after 1340, but some deeds for the west side date back as far as 1301. On the west side is the white Georgian façade of one of the earliest coaching inns: the Hart's Head, known as the White Hart from 1700. It was built on dean and chapter land, and has been an inn since 1497. The site of the Hart's Head first appears in the 1343 Commoner's Accounts; it was bequeathed five years earlier in return for prayers for 'the repose of the soul of Ralph de Lullington'.

SADLER STREET *c1960* W47065

By the 1960s this was a one-way street, as we can see from the 'No Entry' and parking restriction signs. At the far end, on the right, a car emerges through the Dean's Eye into Sadler Street from Cathedral Green. The Midland Bank (right) stands on the site of No 1 Market Place, whose records date from about 1260. The properties along the same side of Sadler Street as the Dean's Eye sit astride the precinct wall. If we look up at the rooftops from the little garden belonging to the Swan Hotel, we can see the two-part building. The front part, facing Sadler Street, was owned by the Bishop on a lease of three named lives. The rear (cathedral) side would be held on a 40-year lease from the Dean and Chapter.

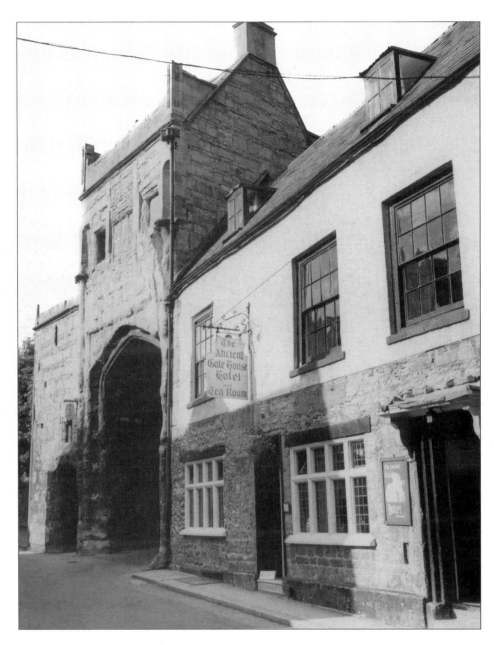

THE ANCIENT GATEHOUSE *c1960* W47071

In 1451, Bishop Bekynton commissioned his 'New Works', which included the Dean's Eye, or Browne's Gate, built in 1453, which connected the cathedral precinct with the city. The Dean's Eye forms part of Nos 20 and 22 Sadler Street, once called the Mitre Inn, now known as the Ancient Gatehouse hotel and tea room and the Rugantino restaurant (a narrow, winding stone staircase inside the hotel leads to the room above the gateway, which is furnished with an antique carved four-poster bed). In the late 1690s there were about five inns in Sadler Street. The Mitre Inn had occupied three other sites here before vanishing by the late 19th century with the arrival of the temperance movement. Wells always had a large number of inns, and by 1900 there were still fifty inns in the city.

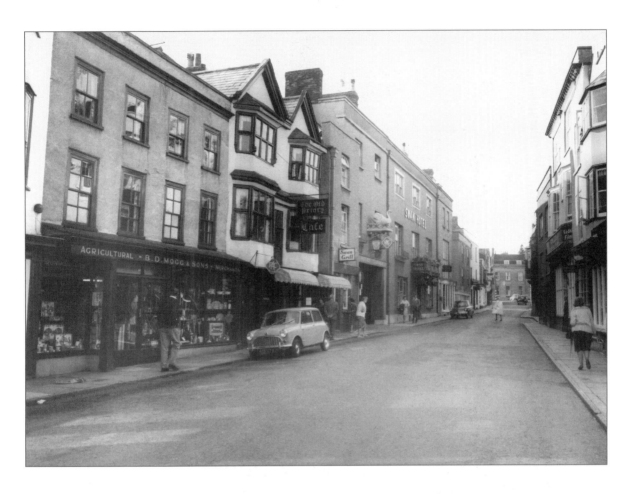

SADLER STREET *c1960* W47076

The Old Priory Café, the gabled building on the left, now a picture gallery, has a 17th-century façade and a medieval jettied front with pargetting (plaster designs). The agricultural merchants B D Mogg & Sons (left) are still trading - their premises are now on the northern outskirts of the city. Sadler Street was subject to an enhancement scheme in 2001, and much of the asphalt road has been replaced by more picturesque material. Exploration of the uncharted territory beneath the street was also undertaken, as the ancient water and drainage pipes needed to be replaced.

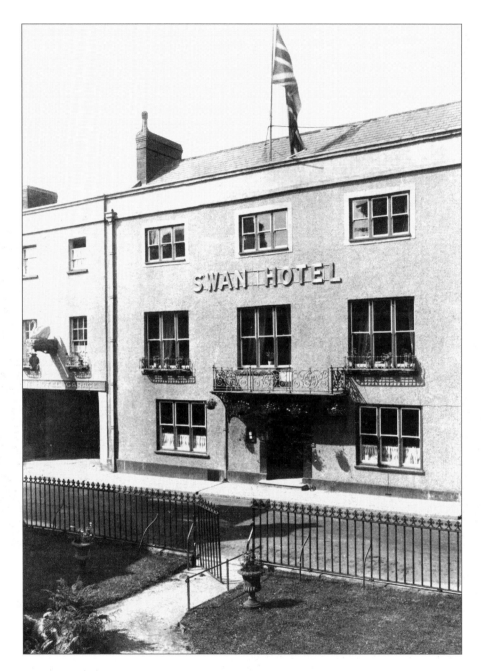

THE SWAN HOTEL *c1920* W47332

The frontage of the Swan Hotel hides its 15th- and 16th-century origins. The window to the left of the swan on its plinth was once a doorway permitting passengers to walk into the hotel from the top of a stagecoach. The little garden was created in 1869. The Swan Hotel, first recorded in 1422 and rebuilt in the 16th century, hosted a feast in honour of Queen Anne of Denmark in 1613. The hotel has some theatrical costumes permanently on show on the ground floor; these were worn by the 19th-century actor Sir Henry (Brodribb) Irving. He was the first actor to receive a knighthood (1895).

THE MARKET PLACE

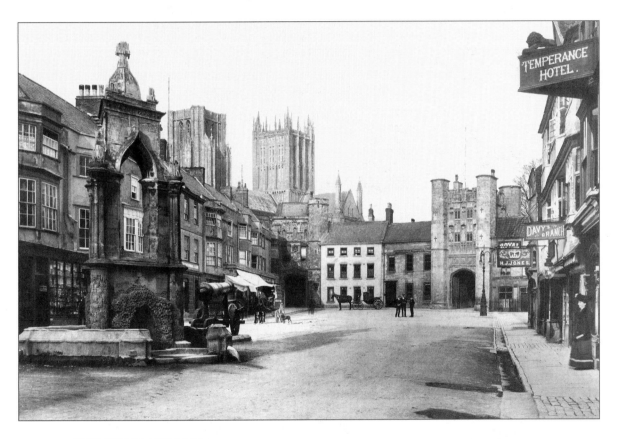

MARKET PLACE *1890* 23894a

The central tower of the cathedral dominates the background. The Bishop's Eye gateway to the Bishop's Palace and the moat is on the right. A door was added to the façade to the left of the Bishop's Eye between 1800 and 1890. In the middle of the Market Place behind the present fountain there used to be a market hall called the Exchequer, built in 1542. In 1685, Judge Jeffreys held his Bloody Assizes following the Monmouth Rebellion (the 'Pitchfork Rebellion') in the Exchequer. Five hundred and forty-three people were condemned. Three hundred and eighty-three were to be transported, and ninety-nine were to be hanged, nine of them in Wells. The executions took place by the Glastonbury road in a field called Gallows Close, now Bishopslea Close. The Exchequer was pulled down in the mid 19th century, leaving space in the Market Place for markets and fairs.

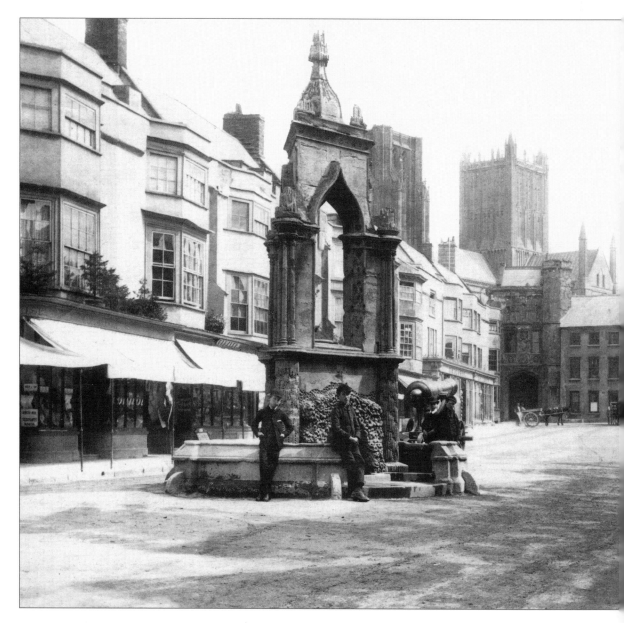

MARKET PLACE *1890* 23894

The 18th-century three-sided stone fountain replaced the 15th-century conduit built by Bishop Bekynton for his grant of a water supply to the city. Bottom right is the channel for Bishop Richard Beadon's gift of water: in 1803, he provided it for 'cleansing and fire fighting'. This supply flows along the channel on the south side of the High Street. The Russian cannon beside the fountain was a souvenir of the Crimean War – it was scrapped for World War II. Note that the only traffic to be seen is a horse and cart in front of Penniless Porch.

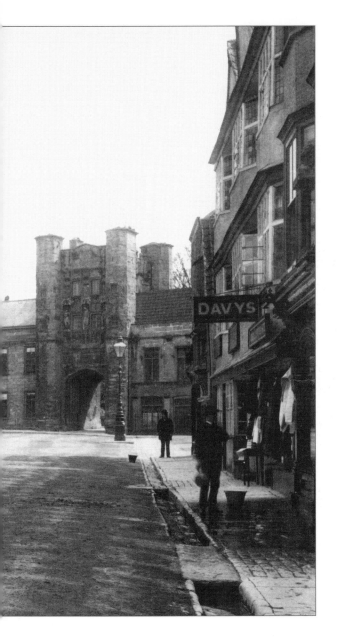

THE Market Place is aligned with the west front of the original Saxon minster church. The present cathedral is reached through the 15th-century stone gateway called Penniless Porch in the left corner of the Market Place. It was called Penniless Porch because beggars would shelter here and ask for alms, as their modern equivalents and street entertainers still do today. Penniless Porch was built by Bishop Bekynton in 1451. The gateway to the right of Penniless Porch is the Bishop's Eye; it leads to the Bishop's Palace and the moat. It too was built by Bekynton in 1451. Both these gateways bear Bekynton's rebus, a pun on his name. This consists of a fire (beck) in a barrel (tun), a signalling beacon on a pole, with the ladder alongside to allow one to light the beacon. These gateways, together with the Dean's Eye in Sadler Street, form part of Bishop Bekynton's 'New Works', together with the twelve houses flanking the northern side of the Market Place, which were built in about 1453.

Wells must be the only city in England with a river running down its High Street. The channels on the south side of the Market Place and the High Street bring spring water from the lake behind the cathedral through the city by a system of lead pipes via the stone conduit in the Market Place. The water was a gift to the citizens from Bishop Bekynton; it also flows through the cellars on the north side of the Market Place, which were part of Bekynton's 'New Works'. Visitors to Wells who are not aware of the springs are concerned that the drains are blocked. Their fears will be allayed if they observe that the water spurts up through the drains into the blue lias channels alongside the pavement, and not down into the drains from the gutter.

▼ THE TEMPERANCE HOTEL *1890* 23894c

The Royal Oak ale-house (its sign also proclaims 'H J Jones Wines & Spirits', centre) opened in 1830, and closed in 1906. William Penn preached from one of the upper windows of the Crown in 1604; the Crown was possibly the building which became the Royal Oak, now incorporated into the medieval Crown Hotel - named 'Crown' since the end of the 16th century. It was previously a wigmaker's house, and the 'house with the green door' in the book 'City of Bells' by Elizabeth Goudge. The Red Lion, in the foreground, dates from 1600. It was a temperance house from 1874 for twenty years. The Crown and the Red Lion hotels were originally three 15th-century timber-framed houses with oriel windows.

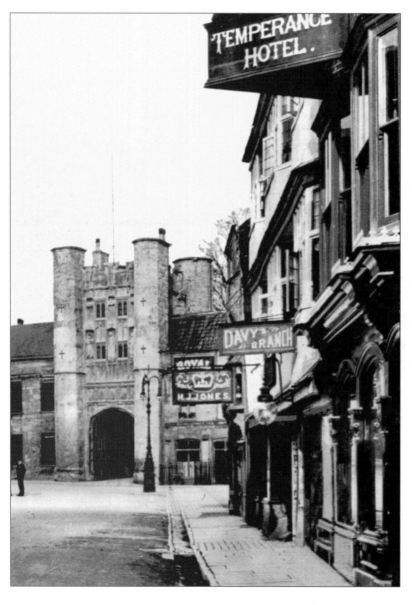

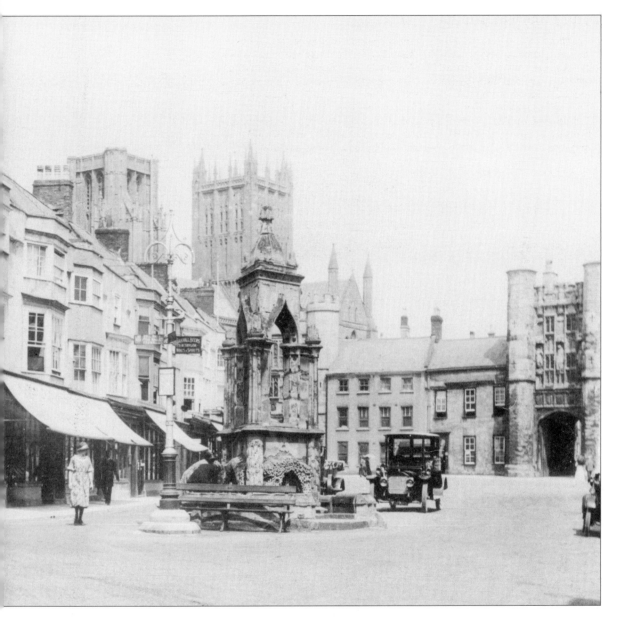

▲ **MARKET PLACE** *1923* 73991

The London Joint City and Midland Bank (established 1836), now the HSBC bank, occupies the site of No 1 the Market Place - the original site dates from 1260. The bank was built where the last two buildings on the corner with Sadler Street once stood, which were Charles Tucker's Wells General Drapery Bazaar and Reakes hardware store. Next door to the bank is a tailor's. There is a new lamp post and a bench in front of the conduit, and the carriage of the Russian cannon can just be glimpsed behind. As a market town, Wells would be expected to have a market cross. There was a High Cross opposite No 1 Market Place from 1414: it was replaced in the 16th century by one which was 9 metres high – it was removed in 1779. Note that there are just two cars - now considered vintage models.

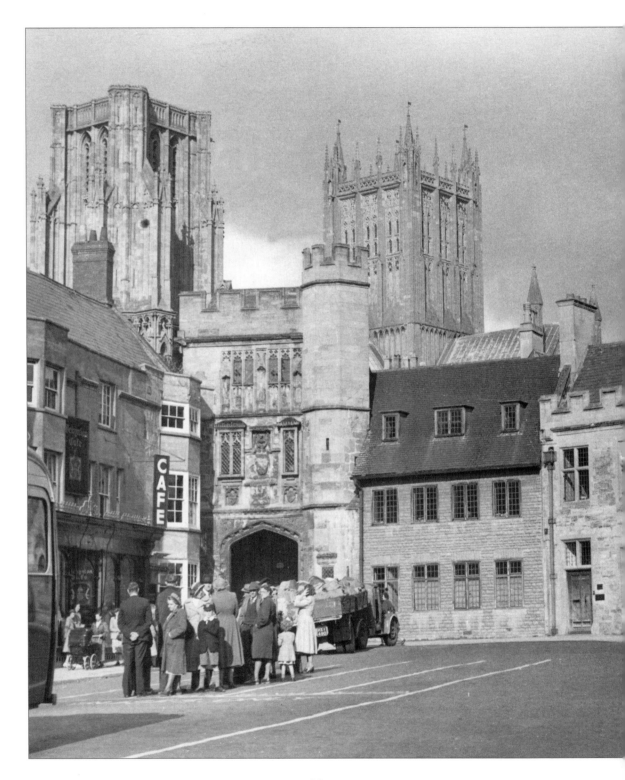

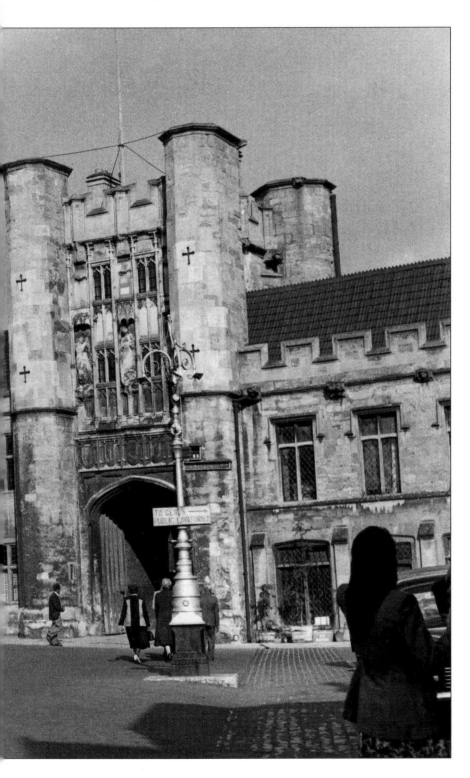

MARKET PLACE *c1945*
W47020

A queue, typical of rationing years, has formed where an air-raid shelter used to be (left). The Bekynton Café behind became Edward Nowell's antique shop, but it is a café again today. Note the bus (far left) – at this time, buses still stopped in the Market Place. Note too the truck parked by Penniless Porch, the carriage-built pram (left), the headscarves, and the hats.

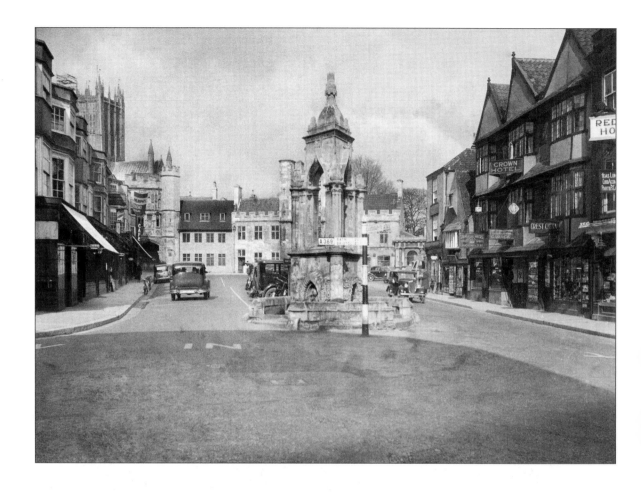

▲ **MARKET PLACE** *c1950* W47324

The sign in the centre, pointing against the flow of traffic today, indicates the A369 to Bath and Bristol - the High Street used to have two-way traffic. The other less visible pointer indicates the A39 to Glastonbury and Bridgwater. Boards (right) advertise food and accommodation for visitors at the Red Lion. Crest China (right) has gone.

▶ **MARKET PLACE** *c1960* W47063

The car park, the gardener tending the flowers on the fountain, the well-used bench beside it - all these are signs of civic pride and the wish to attract visitors to the city. Note the scooter and the motorbike by the sacks behind the fountain: youngsters divided into Mods and Rockers according to their clothing style and motorised steed.

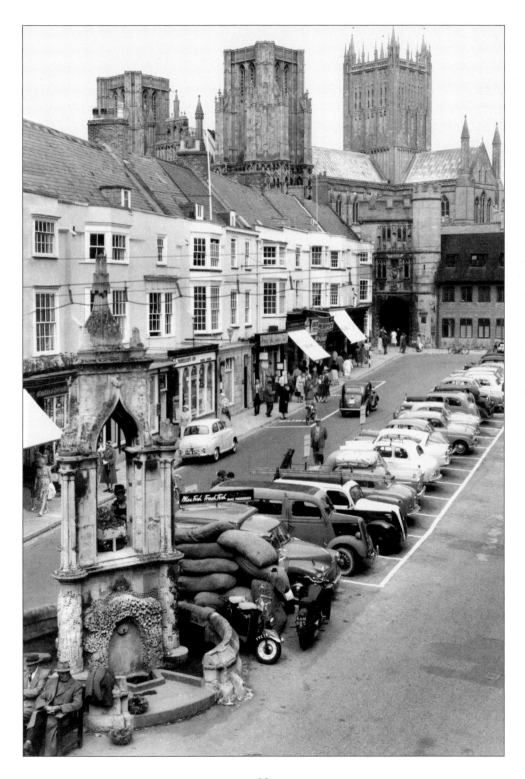

MARKET PLACE
c1960 W47052

By now, the Red Lion Hotel is no longer a temperance house, the street lamp has changed, and motoring organisation signs classifying the hotels now proliferate. Dyer Bros tailor's shop alongside the bank, which we saw in 73991, has become Mac Fisheries (left) - note its van by the fountain. Next door, Cathedral Antiques and the solicitor's premises remain.

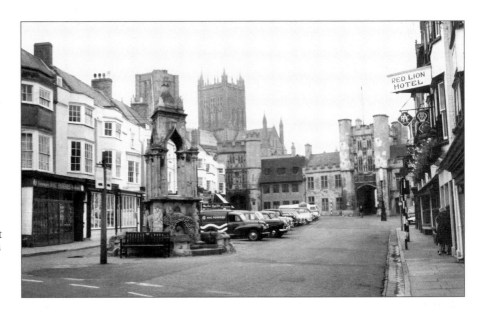

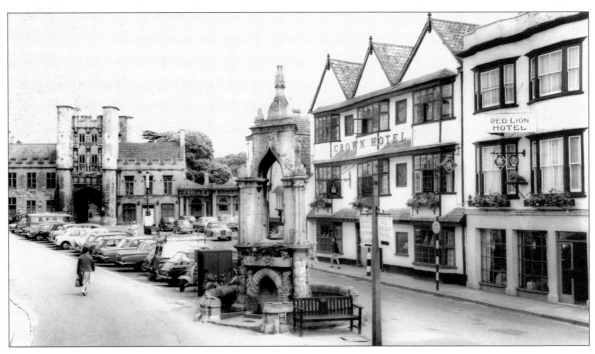

MARKET PLACE *c1965* W47097

The scooters behind the fountain are a symbol of the 50s and 60s. In the background (centre) is the Market House, erected in 1836, which was converted to the post office in 1923 by building between and behind its open colonnade. The hotels are now bedecked with flowers. The area which was once the site of the Exchequer has now become a small car park which has to be cleared twice a week to allow the market to take place. At the end of the 20th century, the Market Place was the subject of an enhancement scheme - the asphalt surface was removed and replaced by cobbles.

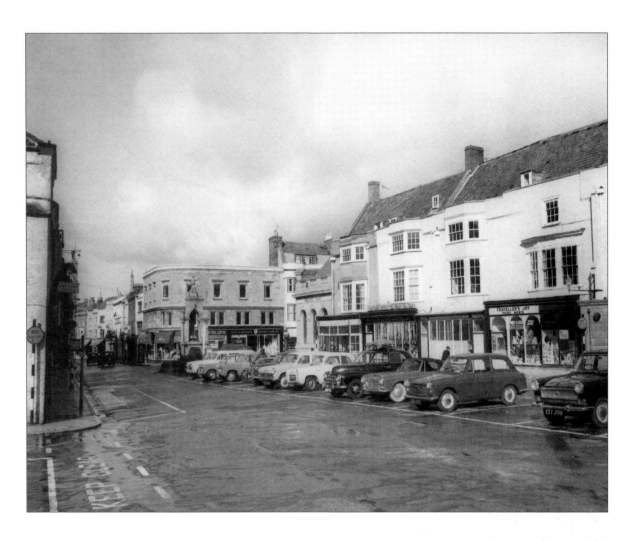

MARKET PLACE *c1965* W47083

This view westwards shows (from left to right) the Midland Bank,
Mac Fisheries, Cathedral Antiques (the Abbey National Building
Society today), a solicitor's premises, and Traveller's Joy travel
agents (Barclays Bank today). Note the bus stop on the corner
(left) - buses no longer enter the Market Place today. The Red
Lion Hotel (left) is being renovated.

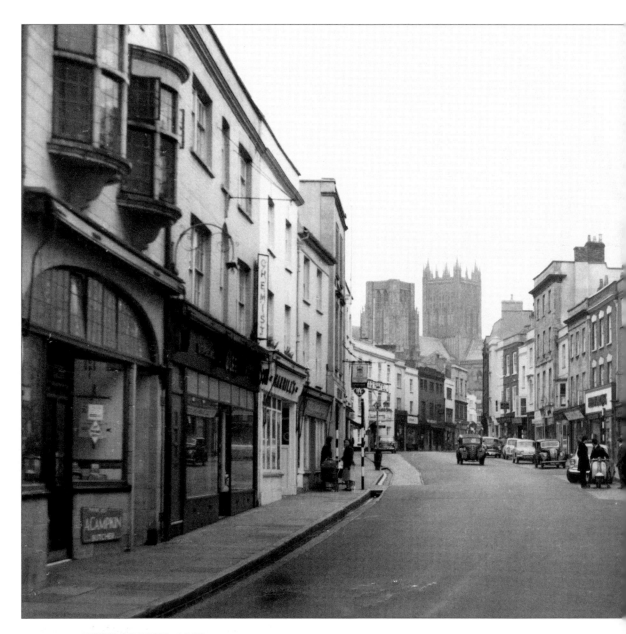

HIGH STREET *c1955* W47051

In the 16th century, down the centre of the High Street there were butchers' stalls known as shambles (from the Anglo-Saxon 'scamel' meaning 'a wooden bench'). The Linen Hall was built over them on pillars; it was rebuilt in the 16th century, and then removed, together with the shambles, in the 18th century in order to widen the road. Campkin, the butcher's shop (left), became the Friendly Friar restaurant. The chemist's next door is a sports shop. Frisby's shoes, marked by the clock on the right, is now Bastin's stationery and gift shop, but the clock remains. The cycle shop to the right is now Curry's. Further down the High Street, opposite Mill Street, No. 58 has a restored shop-front by William Halliday. It appears to be the only example of a late 19th-century revival of the fashion of pargetting (plaster work), perhaps inspired by No 7 Sadler Street.

THE HIGH STREET

IN THE 14th century the High Street was called Cheap Street; the façades date from the early 19th century, and conceal earlier ones. The water channel down the north side of the street carries Bishop Bekynton's gift of water to the town in 1451, while the channel to the south carries Bishop Beadon's gift of water in 1803. The Star was built in 1513 as a coaching inn, while the King's Head tavern, built in 1320 during the reign of King John, was a hostel and refectory for the builders of the cathedral - the 14th-century bar, galleries and market room and 15th-century roof are still visible today. (Both inns are just visible in photograph W47081).

At the junction with today's Broad Street and Mill Street stood the city pump. Wet Lane, in the late 13th century, was downhill from the pump, and under 4 metres wide. It was renamed Broad Street, and in 1821 the Corporation and the Turnpike Company moved the fronts of the modern Nos 2-12 back from the road. The High Street veers right towards St Cuthbert Street and St Cuthbert's parish church. At the corner with Queen Street stands the City Arms inn, the 16th-century inn and gaol from 1589 to 1810. The High Street is undergoing enhancement in 2002, and further excavation may reveal more of the history of this area.

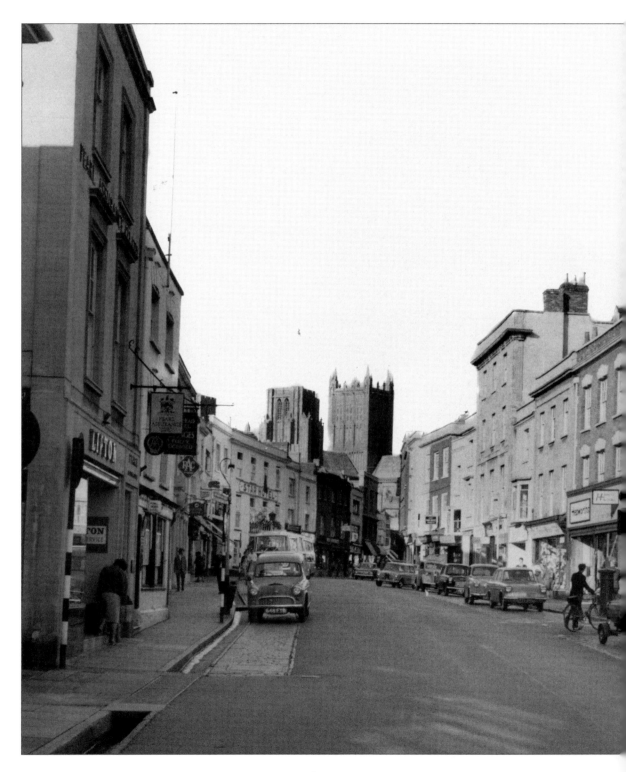

HIGH STREET *c1960*
W47081

Liptons the grocer's (left), a café from 1910 to the 1920s, is now Dixon's. Beside Liptons, the Pearl Assurance sign hides that of the Kings Head. Beyond, Lloyds Bank (established 1835) remains, with the 15th-century Star Hotel visible behind. The pillar box (right) still stands, but Hepworth's has become Superdrug. Next right is now a New Look fashion store; it stands on the site of the Novum Hospitium, where the Vicars Choral lived before 1382. It was also the site of the ancient Christopher Inn (1404-1862), and until mid 1887 it was the Somerset Hotel, with a cast iron covered porch, stone walls and sandstone floors. William Halliday - a self-taught wood carver - lived there. His work was exhibited at the Great Exhibition, and can be seen around the city and in the cathedral. The Co-operative society (right) - now Stokes the greengrocer's and Lewis's – is now a sports shop. Woolworth's remains. On the west side of Guardhouse Lane (the gap between the Co-op and the store next to Hepworth's, right) was the guardhouse for prisoners from the Napoleonic wars - later it became a granary. Just west of Liptons (left), the 13th-century Grope Lane became Grove Lane in 1840, and is now Union Street. The library was built here in 1968, winning a Civic Trust Award.

THE PARISH CHURCH OF
ST CUTHBERT

THIS is the third church to be built on the site. The first was a 9th-century wooden Saxon church. The second was a 12th-century Norman church -the shaft of a Norman piscina remains in the Lady Chapel - and the third church, built in the 13th century in Early English style, was restored in the 15th century. The two side chapels each have a medieval reredos, which were hidden behind plain walls from the time of the Reformation until they were re-dis-covered in 1848. The skill of the medieval craftsmen is still discernible, although iconoclasts destroyed the carvings and plastered over them. The Tree of Jesse, which formed the reredos of the chapel in the south transept, was erected in 1470. The figure of Jesse at the base can still be distinguished, and some of the carvings survived. The niches once contained painted statues surmounted by a statue of Christ.

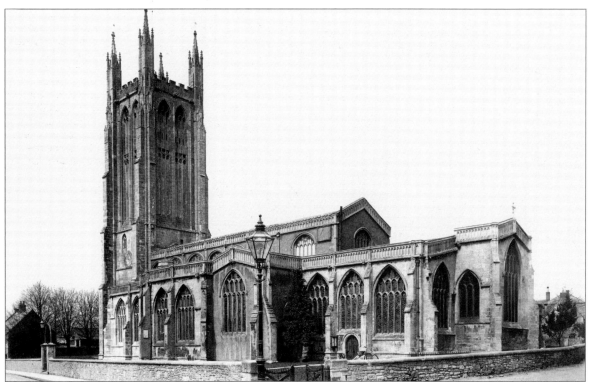

ST CUTHBERT'S CHURCH *1890* 23902

The parish church is built in Perpendicular style, and is the largest in Somerset. It boasts the third highest tower (122ft) in the county. The dedication to St Cuthbert dates from Anglo-Saxon times. The central tower collapsed in 1561. Note the penny-farthing bicycle against the wall by the south door. The war memorial now stands in the gardens to the right of the little door in the south wall.

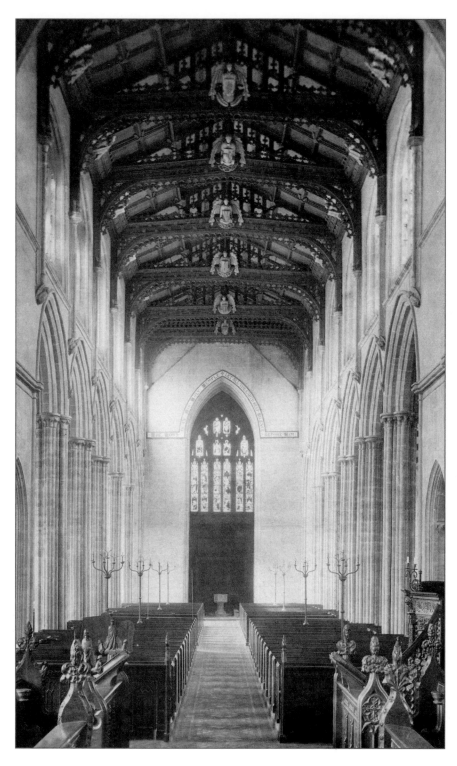

ST CUTHBERT'S CHURCH
The Nave 1890 23904

We are looking towards the west tower. The magnificent painted timber roof with a flight of angels is 15th-century. Note the abutments of the original ridge roof on the back west wall: these date from before the clerestory was added in the 15th century. The tower at the west end was also built at that time. There was once a gallery here for the organ. The Corporation pews in the nave are reputed to be carved from a wooden screen from Glastonbury Abbey. The beautiful Jacobean pulpit (right) has carvings with a shiny patina produced not by the polishing of a zealous cleaner, but by hands lovingly caressing them over time. At the time of the 15th-century restoration, the shafts of the columns were extended by 9ft and the church was made taller; the bases of the pillars differ according to when they were built.

THE
CATHEDRAL

THE first time I saw the cathedral was at night, before floodlighting. It loomed out of the shadows, a man-made cliff. During festival processions around the churchyard, the illiterate medieval peasant would gaze up at the three hundred medieval statues (which were all originally colourfully painted), entranced by the trumpet blasts and celestial singing issuing from the holes beneath the Great West Window, where the back wall of the anterior passage acts as a sounding board, imagining the glory of the Day of Judgement when he would pass on to the joys of Paradise. The cathedral functioned both physically (through the West Front) and in teaching as the gateway to Heaven.

The present cathedral was begun in 1190; it was built in oolitic limestone from Glastonbury Abbey's quarry at Doulting about 12 km away - the stone is still being quarried today. It is the first cathedral built completely in the English Gothic style.

Today, the cathedral still serves for worship, and also as a venue for concerts. The tradition of carving endures too: David Rice carved the head of Master Mason Bert Wheeler (1935-1978) wearing spectacles, which was added to the Chapter House roof, and the head of the groundsman Charlie Clark with his cloth cap and coal sack. By the north porch stand symbols of the four evangelists: the angel of St Matthew, the eagle of St John, the ox of St Luke and the lion of St Mark were carved in Doulting stone by Mary Spencer Watson, and presented to Wells Cathedral by the Jerusalem Trust in 1995.

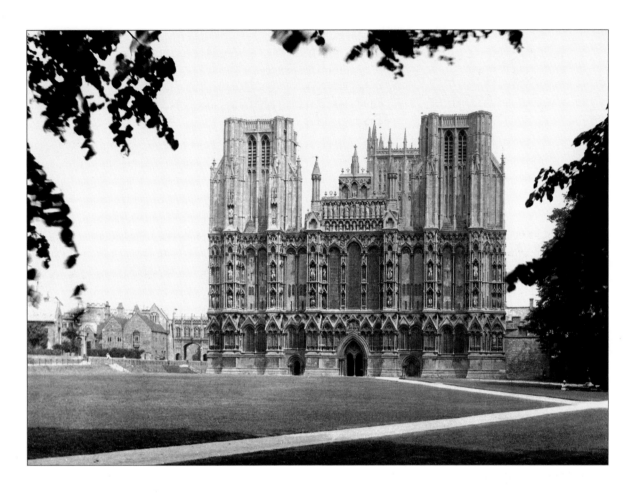

THE CATHEDRAL
The West Front 1923 73993

The proportions of the cathedral give it a massive appearance. The west
towers are built outside the line of the side aisles, making the façade twice as
wide as it is high. The carvings on the west front date from about 1230. Christ
in glory reigns at the top; beneath him are the twelve apostles, then the twelve
orders of angels. The row beneath contains the souls rising from the dead,
lifting their tombstone lids; in the next row are bishops, kings, knights, saints,
martyrs, and virgins. The lower niches to the north contain scenes from the
New Testament, and to the south scenes from the Old Testament, while
beneath these are angels. Over the central doorway is the coronation of the
Virgin, and beneath it a statue of the Virgin and child. Between 1314 and 1438
the central tower was raised to its present height and topped with a spire. The
north-west tower was added in 1430. The south-west tower was built in 1380,
and contains the heaviest ring of ten bells in the world. In 2001 three new
millennium bells were presented to the cathedral. Bishop Bekynton's Chain
Gate (left) links the cathedral and the vicars' dining hall. The cathedral clock
can be seen from the kitchen window, ensuring timely arrival at services.

THE CATHEDRAL
The West Front c1940
W47011

The statues are badly worn by the strong westerly winds (which give the name of 'kill canon corner' to the north-west corner); they were also damaged by the 17th-century iconoclasts, who tried to set fire to the cathedral and destroy the images. The faces on the statues, probably the portraits of local inhabitants, were meticulously painted, despite the fact that the artists and sculptors knew they were not visible from below. One of the knights has bright blue eyes inside his helmet - a shock for the unsuspecting restorer on the scaffolding, peering in! David Wynne sculpted the new statue of Christ in Glory with two seraphim at the top of the west front in 1985 - only the knees of the original remained. It was unveiled in 1986 by the Prince of Wales, patron of the cathedral restoration fund. This view shows the entrance to the cloisters, now housing the gift shop and cloister restaurant. The letter box beneath the lamp post has gone. The sign on the far right of the picture directs visitors to Wells Museum on the left.

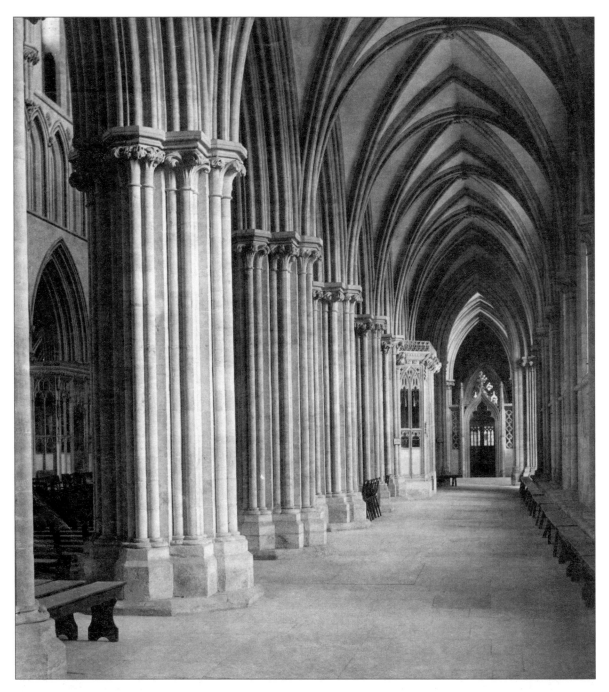

THE CATHEDRAL, *the Nave, South Aisle 1890* 23881

The stone bench along the wall was the only seating in medieval times, and origin of the saying 'the weakest go to the wall'. The south aisle leads to Chancellor Sugar's chantry chapel, which juts out on the left of the aisle. The south transept, beyond, contains some of the more famous carved capitals.

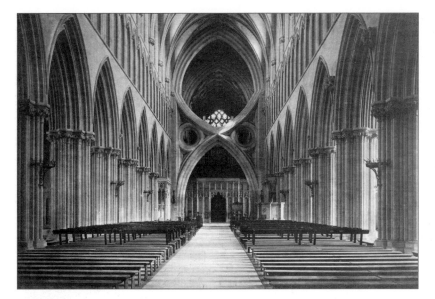

THE CATHEDRAL
The Nave looking East 1890
23879

The beautiful 14th-century scissor arches are the most striking aspect of the nave. Some visitors imagine that the scissor arches are modern, but they were added in 1340 under the central tower in order to give it extra support: the additional weight of the spire and the fact that the cathedral was built so close to the springs caused the tower to tilt. In 1438 the tower burnt down, but the arches remain. Today, the benches have gone; the altar stands in front of the arches, surrounded by elegant limed oak seats installed in 1997.

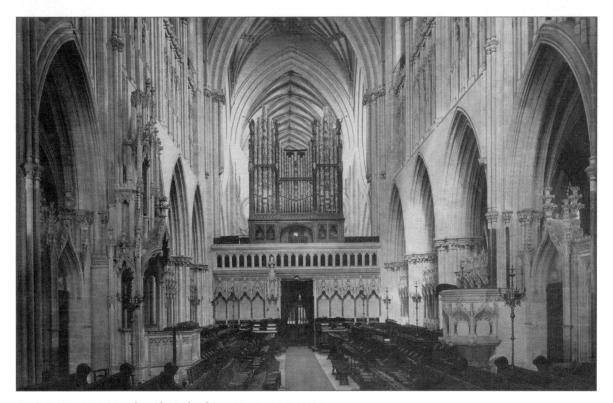

THE CATHEDRAL, *the Choir looking West 1890* 23885

This is the oldest part of the cathedral - the stiff-leaf carvings on the capitals of the north-west side are simpler in design than those east of this point. The bishop's seat or 'cathedra' is on the left.

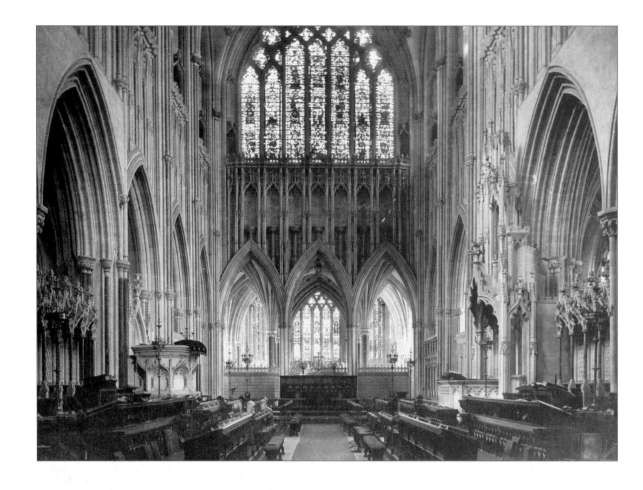

THE CATHEDRAL
The Choir looking East 1890 23883

Above the High Altar, we can see the Great East or Golden
Window with its magnificent medieval stained glass Tree of Jesse,
which survived undamaged despite the iconoclasts; it is one of
the largest and most complete 14th-century windows in
existence. The stalls in the choir have carved misericords.

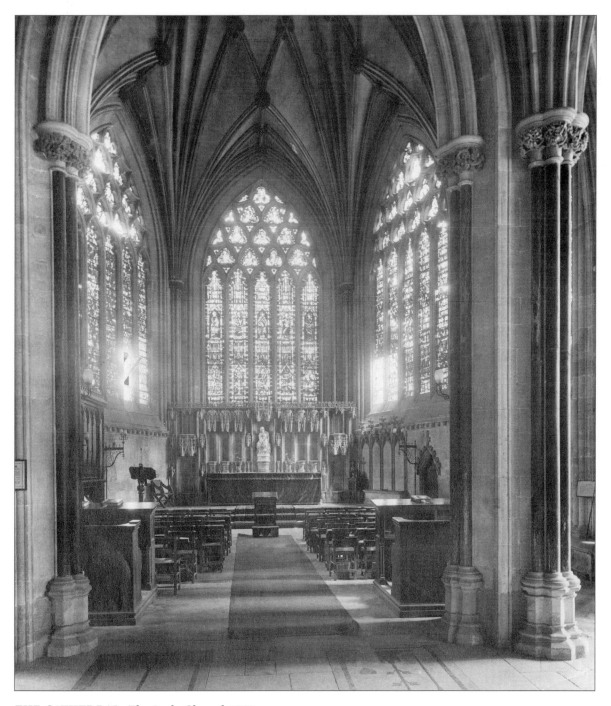

THE CATHEDRAL, *The Lady Chapel 1923* 74001

Today the Lady Chapel has been set up as a modern semi-circular area of worship. The altar stands in the centre of the chapel, emphasising the shape.

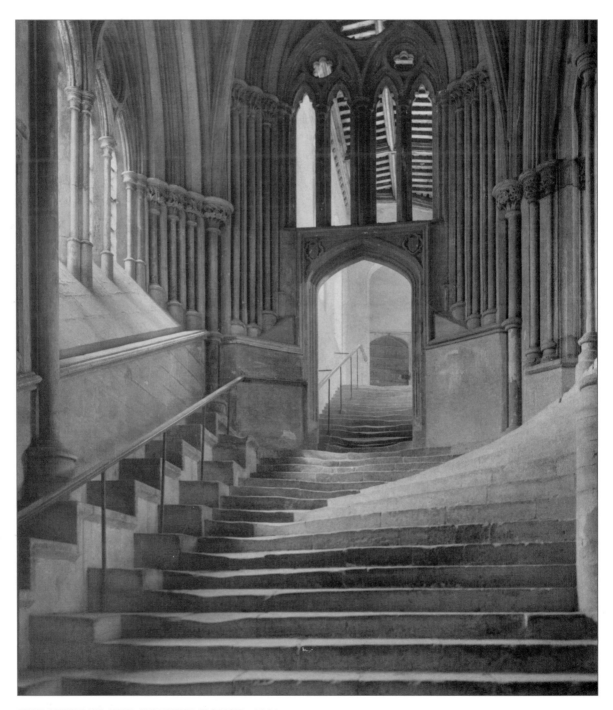

THE STEPS TO THE CHAPTER HOUSE *c1900* W47301

The roundels to the left of these 13th-century steps contain some of the oldest medieval glass in the cathedral. The steps veer elegantly to the right to the chapter house, and extend ahead over the 15th-century chain gate.

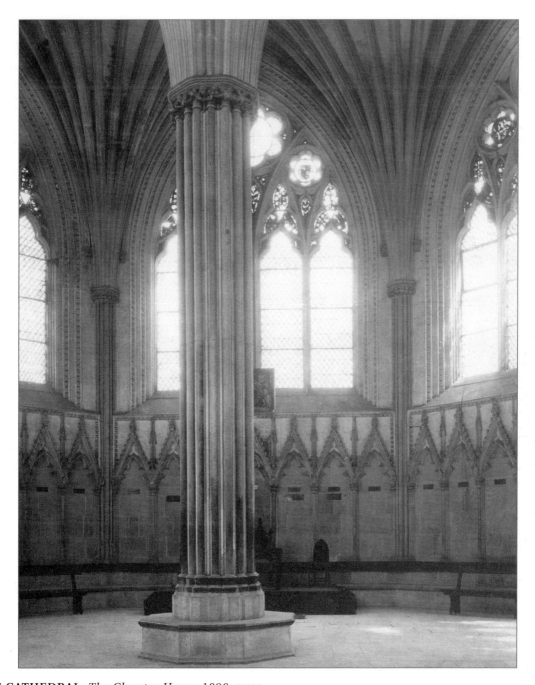

THE CATHEDRAL, *The Chapter House 1890* 23891

The chapter house was completed in about 1306. Behind the pillar is the bishop's seat, and each member of the chapter has his own stall. The carved faces on the walls have survived (some of them are comical), and the bosses in the vault and some pieces of original medieval glass remain. After speaking at trials, the witnesses were kept seated around the central pillar, to prevent contact with those waiting outside.

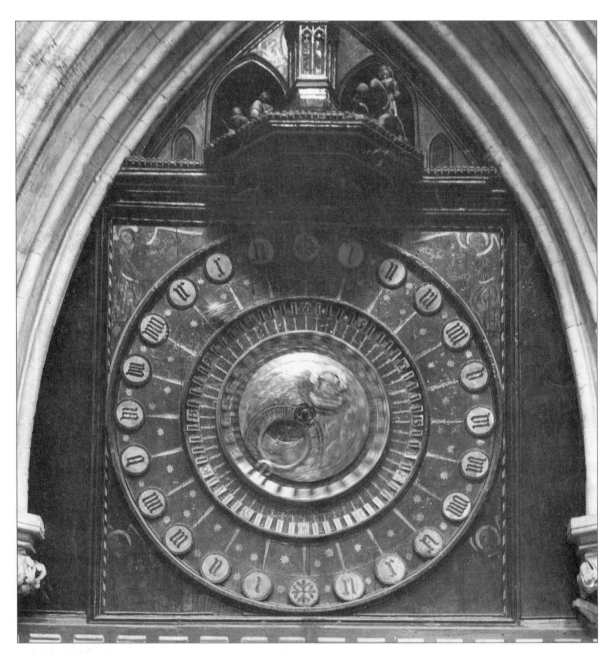

THE CATHEDRAL, *Lightfoot's Clock 1892* 31340

The astronomical clock, once thought to have been built by Peter Lightfoot, a monk at Glastonbury Abbey, was constructed in 1392 and has three dials. It is the second-oldest mechanical clock in Britain still working - the original works of the Wells clock still function in the Science Museum in London. Only Salisbury's clock is older, but it has no face. Knights joust above the dials; the same knight is struck back on his horse at every round. The clock shows two sets of twelve hours, the minutes, the sun's position, the moon's phases and the date of the lunar month. The visible parts of this clock are original, and were last repainted in 1727.

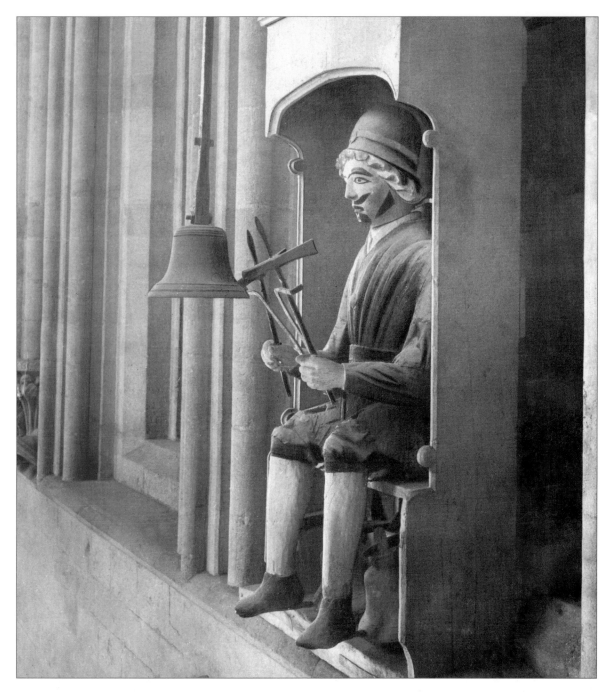

THE CATHEDRAL, *Jack Blandiver 1906* 55157

In the stonework to the right of the clock sits a medieval mechanical wooden puppet called Jack Blandiver; he was repainted in the early 17th century. He kicks the bells beneath him at the hour and quarter hour, and hammers the hour on the bell in front of him.

53

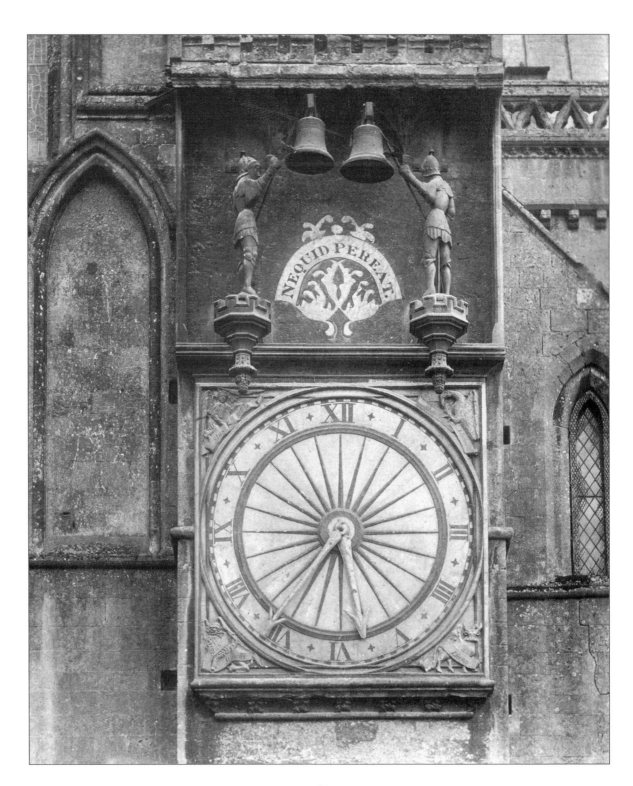

◀ **THE CATHEDRAL,** *The Clock 1906* 55156

This is the outside dial of the medieval clock. The figures and face of the outside clock are a hundred years later than those inside; the bells are struck by the knights on the quarter hour. The inscription 'Nequid pereat' is a quotation from St John's Gospel, and means 'Let nothing perish (or be lost)', referring to the church fabric and the passage of time.

▶ **THE CATHEDRAL,** *The Clock c1960* W47339

The outside face of the clock was replaced after 1824 with one set of hours instead of two. Compare this photograph with photograph 55156: the clock has obviously been restored since 1906. Note the symbols of the Evangelists at the corners.

▼ **THE CATHEDRAL,** *The Quarter Jacks c1920* W47329

This photograph shows the two knights removed from their places for restoration. They wear late 15th-century armour and strike the two bells on the quarter hour.

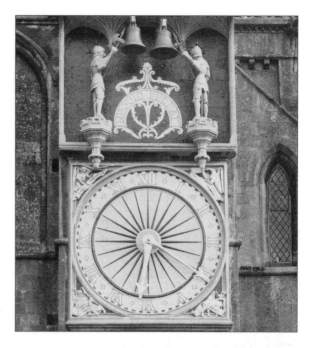

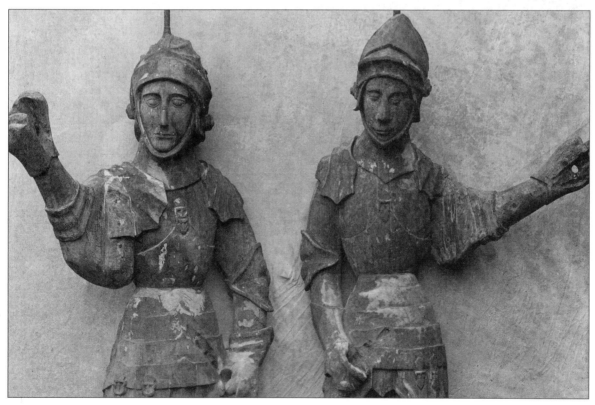

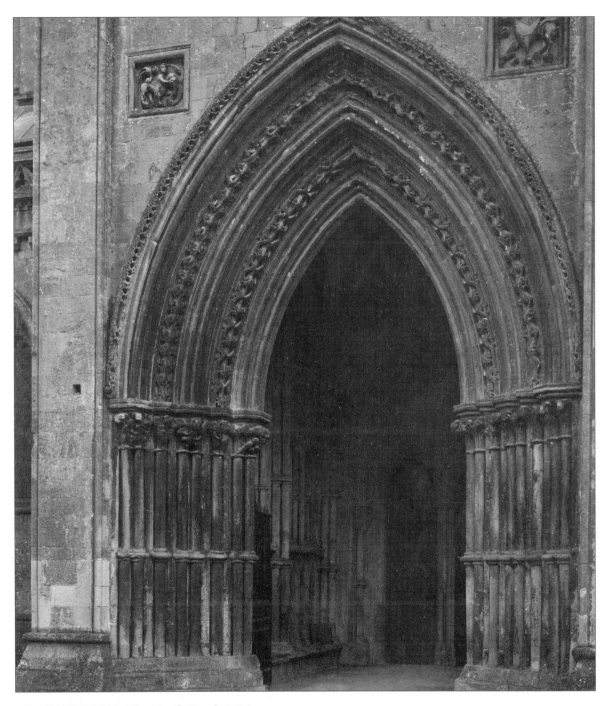

THE CATHEDRAL, *The North Porch 1890* 23876

This beautifully carved porch, dating from 1230, was the main entrance to the cathedral. In a small room above the porch there is a plaster drawing-floor onto which the master mason drew his designs.

THE CATHEDRAL PRECINCTS

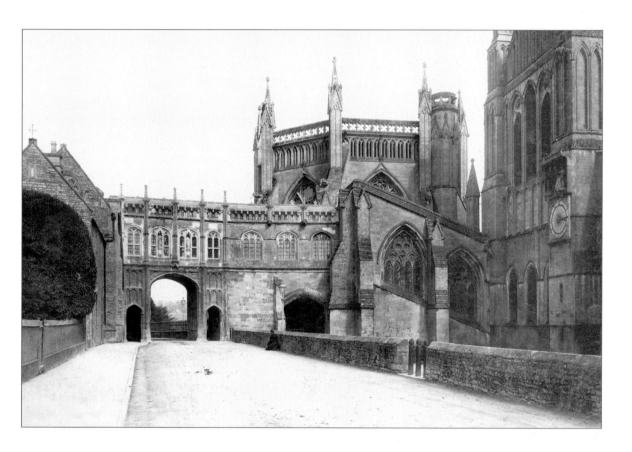

THE CATHEDRAL
The Chain Gate 1890 23875

The Chain Gate, close to the north porch, was built by
Bishop Bekynton in 1459-60 as a covered passage-way
for the vicars choral to cross from their hall to the
cathedral.

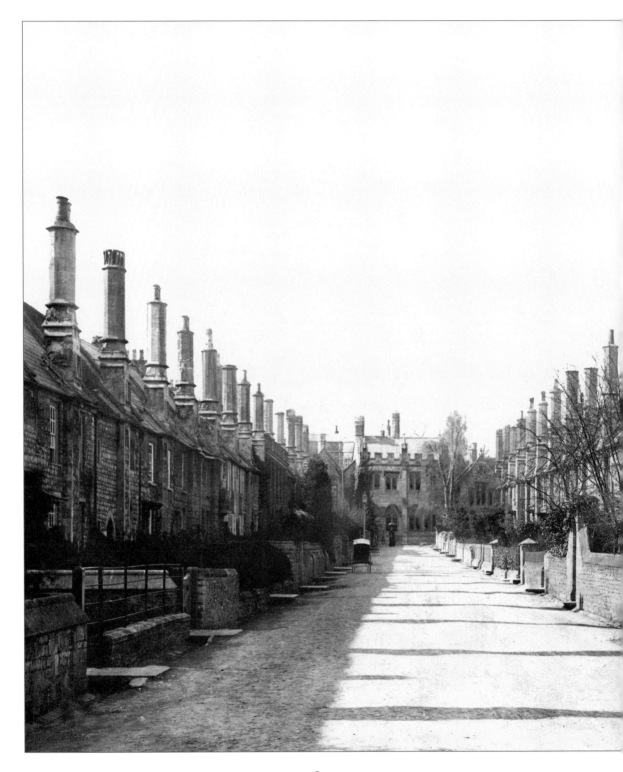

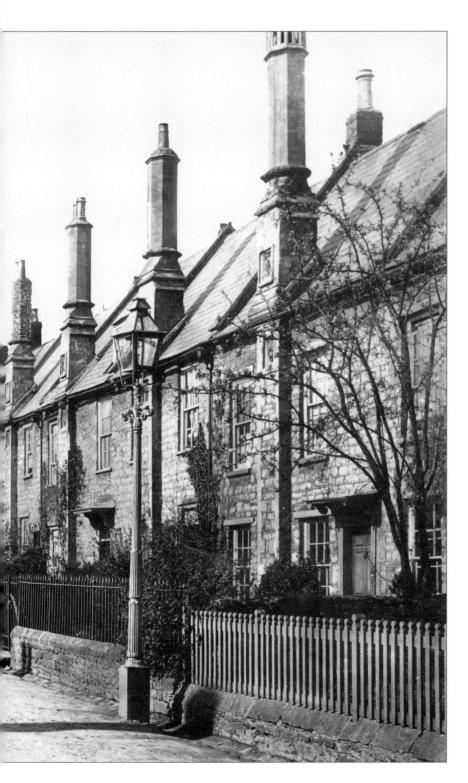

THE CATHEDRAL
AND VICARS' CLOSE
1890 23901

This is the oldest continuously inhabited medieval street in Europe, completed in 1382. Here the vicars choral, or the canons' vicars, lived. These men were not always priests; they stood in for the canons, and sang in the choir during the cathedral services. (The canons were clerks, and among the few people who could read and write in the Middle Ages, so they would travel around doing clerical work). Before this close was built, the vicars choral lived in the town, and then in the Novum Hospitium in the High Street (photograph W47081). The houses are now occupied by cathedral employees and the vicars choral.

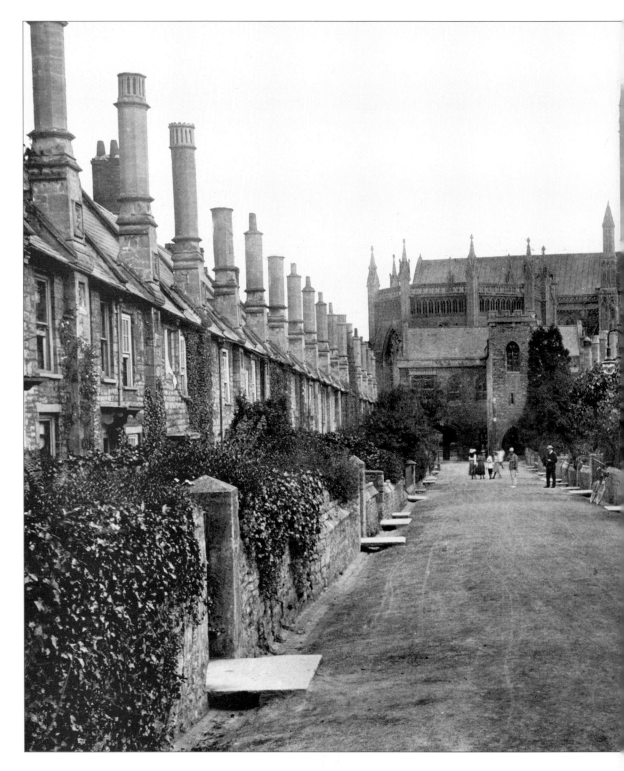

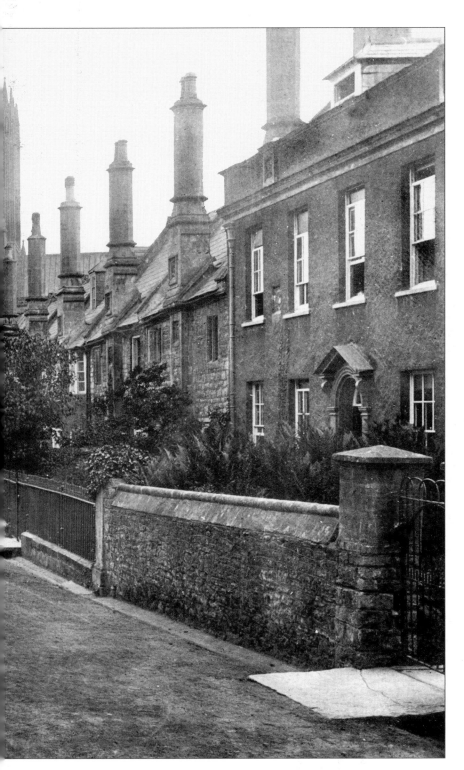

THE CATHEDRAL AND VICARS' CLOSE
1906 55155

The road offers an optical illusion: it seems longer than it is, being narrower at the north end by 2.7metres. Bishop Bekynton's money was used to raise the chimney height. The tall chimneys bear the arms of the See of Bath and Wells, with the arms of the College of Vicars alternating with Bekynton's personal arms. Below these are the arms of the three executors of Bishop Ralph's will: Hugh Sugar (3 sugar loaves), Richard Swan (a swan), and John Pope (a Talbot dog). Recent excavations show that the chimneys form part of the original foundations. This view looking towards the cathedral shows the Vicars' Hall at the far end. Note the adults and children, and the bicycle propped against the wall on the right. The boards over the gutters no longer exist, and the road is now cobbled.

THE CATHEDRAL
from the North-East
1890 23874

Here we see the Chapter House, on the left, and the Chain Gate, to the right of the photograph. The entrance to Vicars' Close is just before the Chain Gate and on the right.

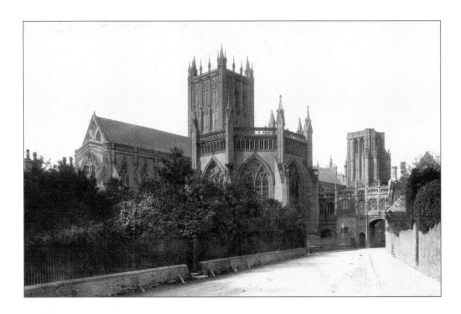

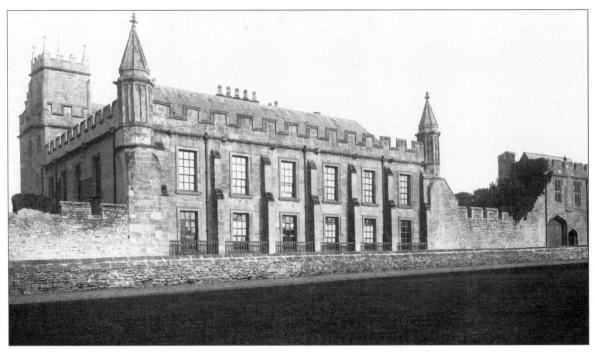

THE CATHEDRAL, *The Deanery 1892* 31341

The Old Deanery on the north side of the Green is a large 15th-century building with an inner courtyard. In 1497 Henry VII stayed here after the Perkin Warbeck uprising. William Turner MD (1508-1568), 'Father of English Botany', cultivated his herb garden behind the battlemented wall while he was Dean of Wells. New windows were installed under Dean Bathurst (1670-1704), a friend of Sir Christopher Wren. The original 15th-century buttresses between the windows and the original battlements remain.

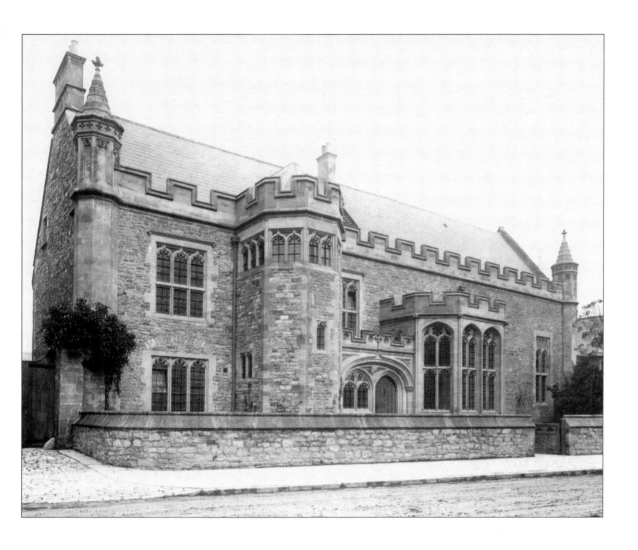

NEW COLLEGE *1892* 31342

The battlemented building opposite the North Porch, No 9 Cathedral Green,
currently the Cathedral Music School, was originally a canonical house re-built in
the 15th century, home of Polydore Virgil, Archdeacon from 1507-1554, an Italian
scholar. He wrote most of his 26-volume 'Anglicae Historiae' while in this house.
This 'History of England' became compulsory reading in all schools under
Elizabeth I. He was chamberlain to Pope Alexander VI, and acted for the Italian
Bishop of Bath and Wells, Cardinal Adriano de Castello (1504-1518). The house
later became a brewery, but it was restored and was the theological college from
1888 to 1971. Next door is the 16th-century Chancellor's House, which is now Wells
Museum. This was one of the houses held by the bishop and granted to the
canons. Recently, extensive excavations in the garden revealed pottery and
ceramics dating back to late Saxon times.

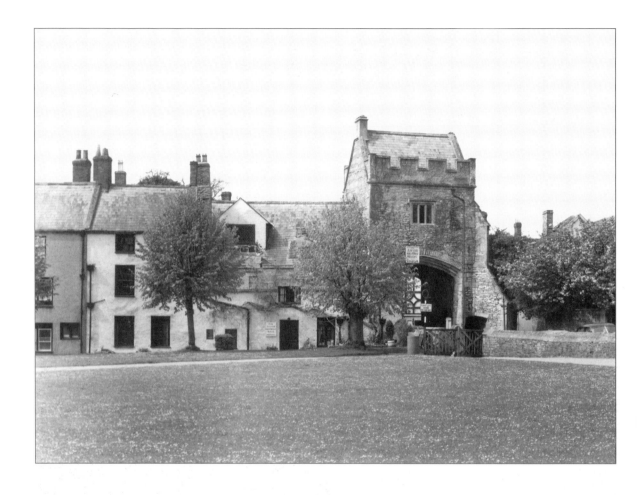

THE ANCIENT GATEHOUSE *c1960* W47340

The 'Turn Left' sign by the gate to the churchyard shows that traffic was still passing under this arch at this time, and that Sadler Street beyond was already a one-way street south towards the High Street and Market Place. If we pass through Penniless Porch into the Market Place, and then turn immediately left through the Bishop's Eye, we will reach the moat and Bishop's Palace.

THE BISHOP'S PALACE

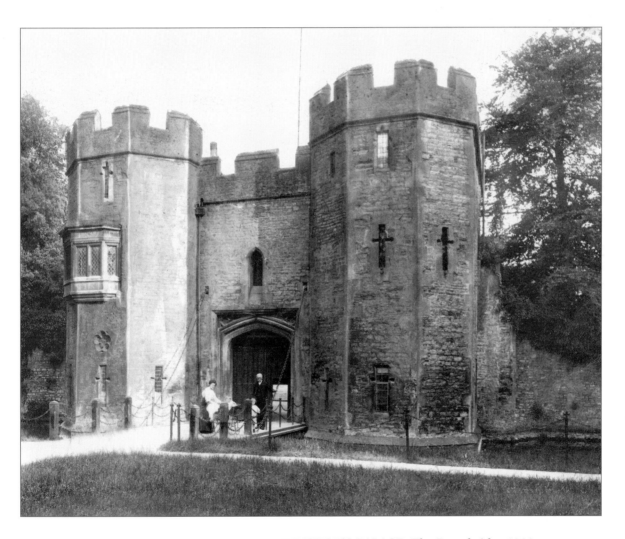

THE BISHOP'S PALACE, *The Drawbridge 1906* 55158

The drawbridge was last raised as a precaution during the Bristol riots at the time of the Reform Bill in 1831, when the mob threatened to enter and wreck Bristol Cathedral.

65

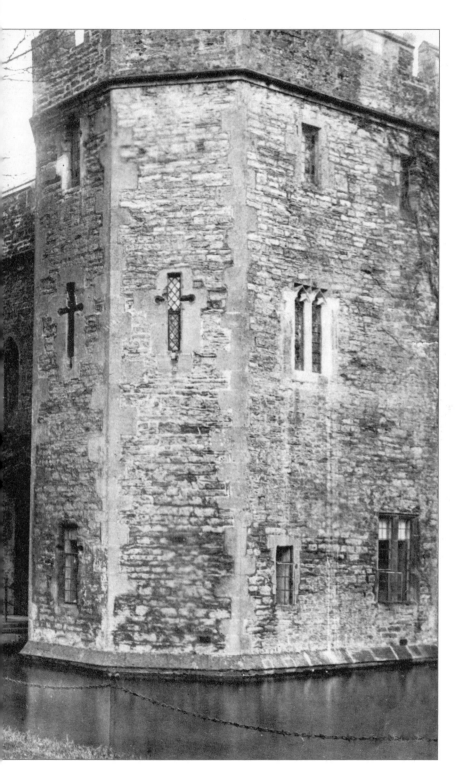

**THE BISHOP'S
PALACE**
from the Moat 1890
23898

The drawbridge was
converted to a road bridge
in the 1930s.

67

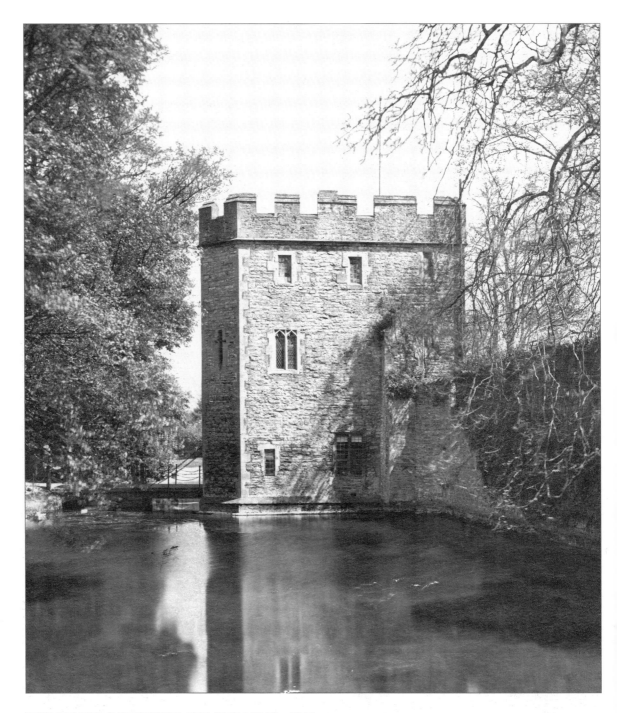

THE PALACE GATEHOUSE AND THE MOAT *c1900* W47303

The 14th-century gatehouse was built sturdy enough to withstand siege but was never required to do so; the moat was formed in 1340.

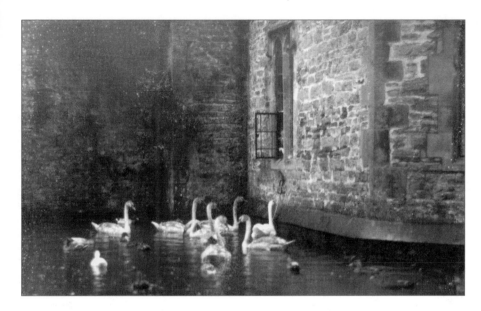

SWANS ON THE PALACE MOAT
c1920 W47317

Since about 1969, the swans on the moat have been trained to ring the bell to be fed; they were trained originally by Bishop Hervey's daughter in the 19th century.

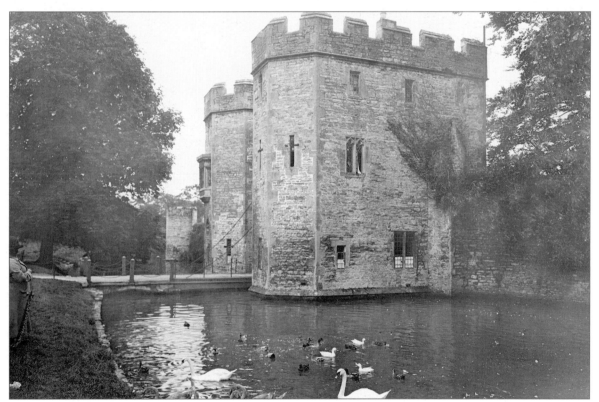

THE BISHOP'S PALACE AND THE DRAWBRIDGE *1923* 73991A

The swans and the ducks have always been a popular attraction.

THE BISHOP'S PALACE *1890* 23899

The central block of the present-day Bishop's Palace (the Henderson Rooms) was built by Bishop Jocelyn (1206-44). The rooms are now used for concerts, conferences, and weddings. The chapel, on the right, in the Decorated style, was added in about 1290.

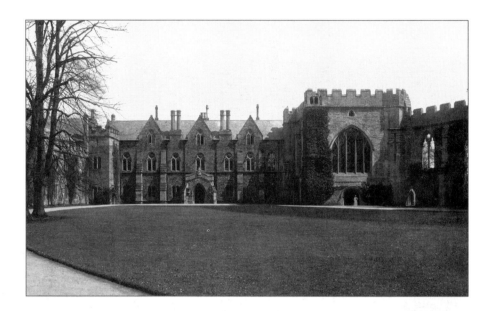

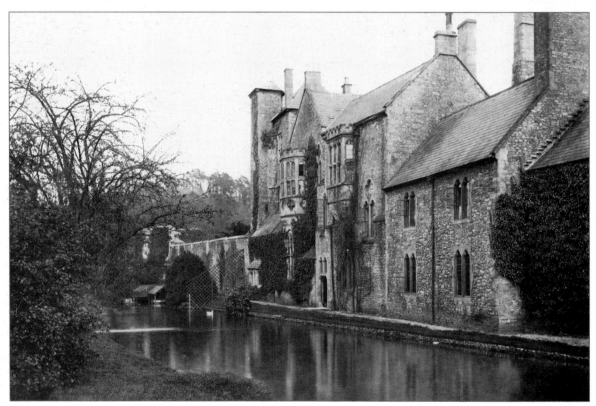

THE BISHOP'S PALACE *1890* 23897

The only difference between this and photograph 7024 (opposite page) appears to be the amount of creepers on the walls.

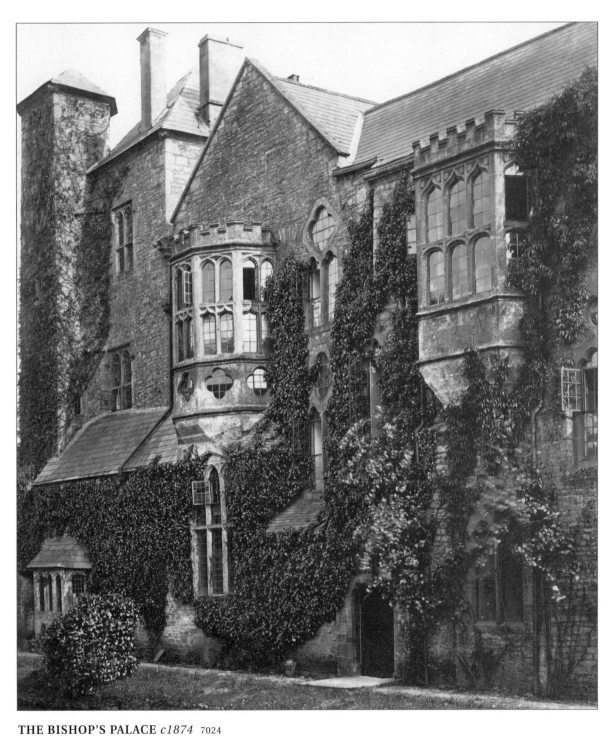

THE BISHOP'S PALACE *c1874* 7024
This north range of buildings is used today by the bishop as living quarters.

THE BISHOP'S PALACE, *The Ruins* *1890* 23895

Bishop Burnell built the great Banqueting Hall in about 1290. It was ruined in the 16th century when Sir John Gates purchased its timber, lead and glass. Note the central tower and the two western towers of the cathedral to the right of the photograph.

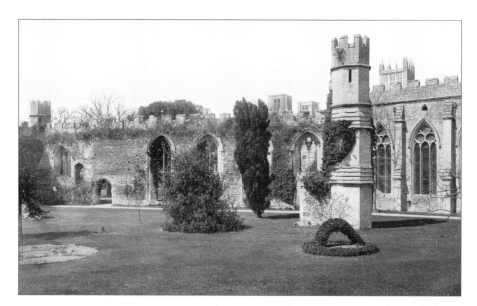

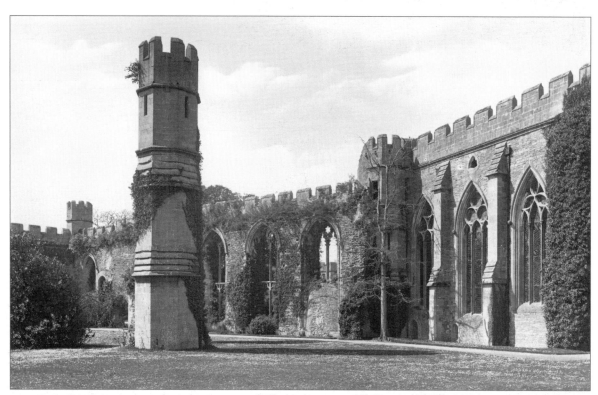

THE BISHOP'S PALACE *c1900* W47305

In the 19th century, Bishop Law destroyed part of the Banqueting Hall so as to have a fashionable ruin in his garden. It has since served as a dramatic backdrop to concerts and plays.

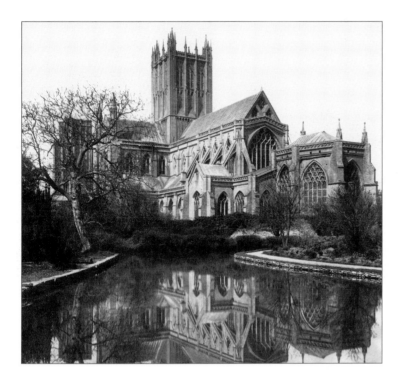

THE CATHEDRAL
from the South-East 1890 23869

This view shows the cathedral reflected in the lake in the bishop's garden, where the bubbles in the water reveal the presence of the spring beneath.

THE CATHEDRAL
from the Gardens 1890 23871

This photograph also looks from the south-east. The gardens behind the cathedral and the lake were used as allotments until the end of the 20th century, when it was decided to turn the area into an arboretum.

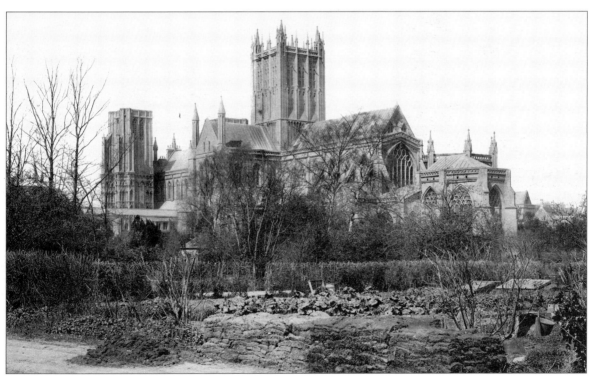

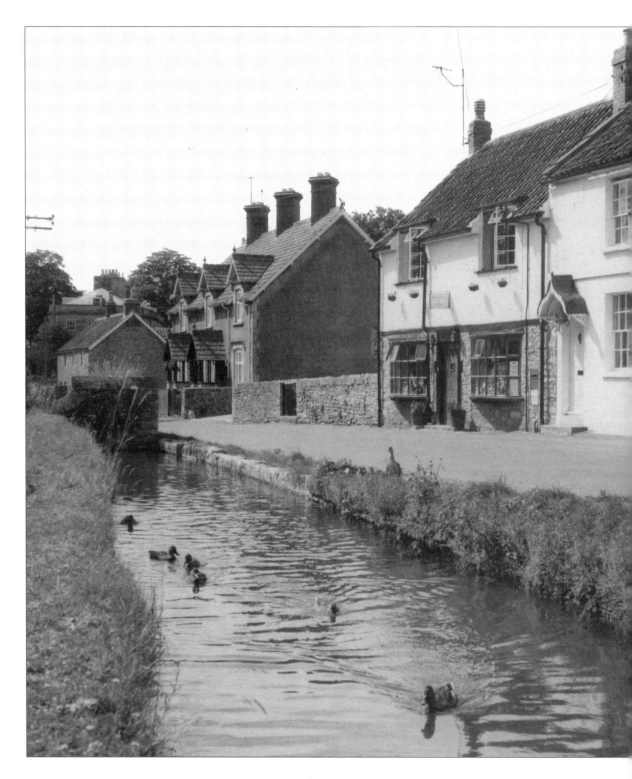

THE VILLAGES

WE LEAVE Wells along the Liberty and the Shepton Mallet road; we pass Tor Woods, where the Chilcote conglomerate stone used in many of Wells' buildings is still quarried. The road meets the Wells by-pass at Dulcote. Dinder is about two miles east of Wells. The road continues through Croscombe, which was once a town and was granted a charter from Edward I for a fair and a market. Then the road winds through the 'cross-combe' by the little river called Doulting Water, misnamed the River Sheppey years ago. It rises at Doulting, near Shepton Mallet, at St Aldhelm's Well, renowned as a healing spring - here St Aldhelm lived and died. The villages along its course owe their prosperity to the woollen cloth industry, as this water fed a great number of mills.

DINDER, *High Street c1965* D249007

This photograph looks west. The ducks still paddle on the river beside the main road, but the Post Office and Stores (centre) is just a house now. Note the cast-iron boot scraper to the left of the doorway on the right. Dinder House was built in Georgian style by the Rev William Somerville in about 1800. It is now the headquarters of Shoon, an international company marketing clothing and footwear.

DINDER
General View c1965
D249003

The name Dinder may derive from 'denrenn', meaning 'den between two rhyns (hill ridges)'. Close by is Maesbury, an Iron Age hill fort 300 metres across. The parish was a prebend of Wells Cathedral before the Norman Conquest. The church of St Michael, originally Norman, was enlarged and partly rebuilt in Perpendicular style in 1460. There is a Jacobean stone pulpit inside.

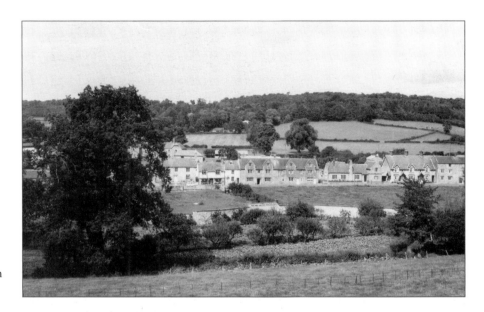

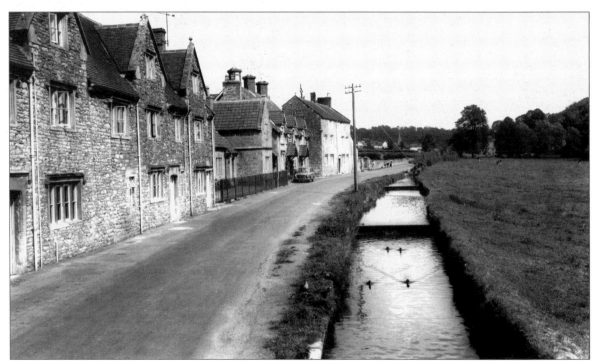

DINDER, *High Street c1965* D249004

We are looking east. The village stands on the north bank of Doulting Water, also known as the River Sheppey. Thus the name of the village may also derive from the words 'dun', meaning 'a hill', and 'dwr', 'water'. The manor was held by the Rodney family of Rodney-Stoke for many centuries until it passed to the Somerville family by marriage. Today, alpacas graze by the Manor House.

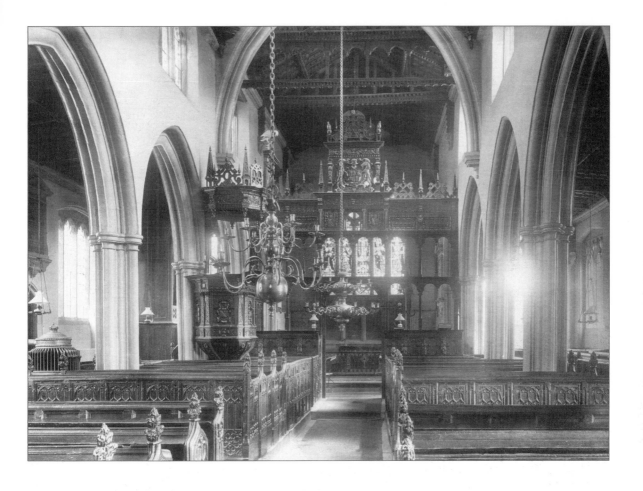

CROSCOMBE
The Church 1899 44103

The 15th-century parish church of St Mary the Virgin is built of Mendip lias and Doulting stone, and has a stone spire 108ft high. The piers of the aisle arcades are 14th-century. Note the Jacobean pulpit and the two brass candelabra; the smaller one dates from 1707, and the larger one, of about 1850, was sold to Croscombe church by St Cuthbert's in Wells when gas was installed there. The 17th-century screen bears the Royal arms of James I and those of the Fortescue family, lords of the manor, whose 15th-century manor house rose behind the church. The remains of its great hall became the Baptist chapel, now preserved by the Landmark Trust and rented to holidaymakers. The 15th-century rectory was once occupied by a treasurer of Wells Cathedral, Thomas Harries, rector from 1490 to 1511 - it is now called the Old Manor. The initials HS in the fan tracery of the ceiling are those of Hugh Sugar, treasurer from 1460 to 1489.

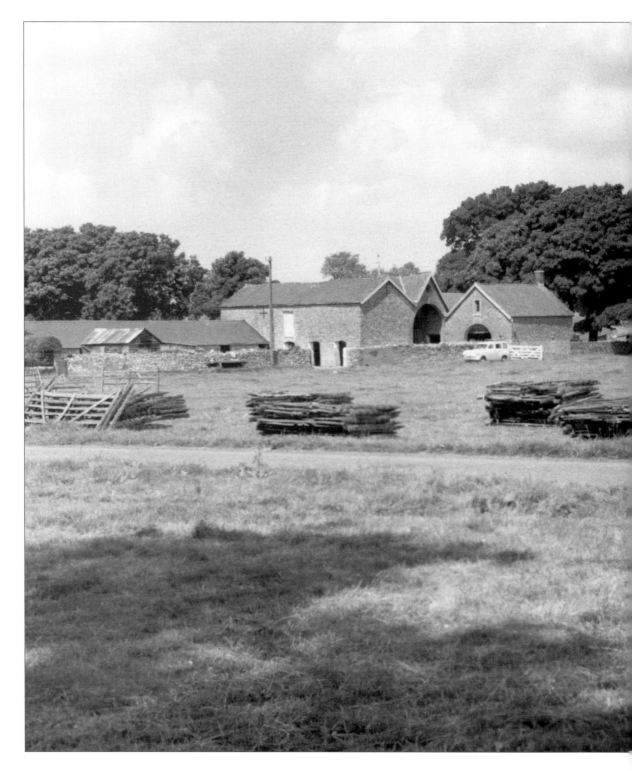

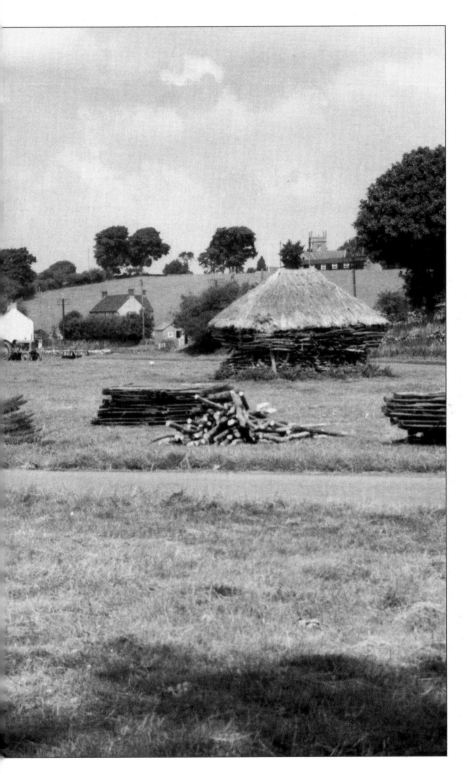

PRIDDY
The Green c1960
P385006

The village of Priddy in the Mendip hills gave its name to one of the four mineries of Mendip. Lead was mined here before the Romans arrived in 43AD. The rotting piles are hurdles, which used to be stored on the Green until they were required to pen the sheep at the annual fair. They are no longer used, but one stack of hurdles was fully restored and thatched in 1997. A time-capsule was put in the base, and a notice explains that they represent those previously used at Priddy Fair in August every year since 1348, when the plague at Wells caused the fair to be transferred here. Note the old tractor (centre) by the white building.

RODNEY STOKE
The Village c1955
R410008

Rodney Stoke was also known as Stoke Gifford; it lies 5 miles from Wells on the Cheddar road. The signpost to the right points to Wedmore, just over 4 miles away. Note the advertisement for Mansion Polish on the end wall of the house which used to be the Post Office (left). There is no longer a post office or a shop in the village.

RODNEY STOKE, *Bucklegrove Guest House c1955* R410020

This building is no longer operating as a guest house; the caravan and camping park is now the main business, and it has had an indoor swimming pool since about 1980. King John granted the manor of Rodney Stoke to Sir Osbert Gifford, and it was transferred by marriage to Sir Richard de Rodney. The 17th-century manor farmhouse boasts a six-seater WC. The 12th-century church of St Leonard is now in Perpendicular style.

RODNEY STOKE
The Rodney Stoke Inn c1955 R410007

This building was erected in 1911 when the original inn burnt
down. There has been an inn on this site since the 12th century;
it was originally a cider house, part of an orchard. It now has a
caravan park and a restaurant. The walnut tree on the left is over
a hundred years old and subject to a protection order. The son of
an earlier landlord died on the Titanic in 1912.

WOOKEY HOLE CAVES
The First Flight of Steps
1896 38937

Situated at the foot of the southern slope of the Mendips, the caves were named after the original village of Wookey, about two miles away. These photographs were taken when there was no electricity, and the caves were visited by torchlight. Today, these steps are safer, but still uneven. The first guided tour was in 1703, but in 1702 the poet Alexander Pope had already shot down a number of beautiful stalactites to decorate the grotto at his home.

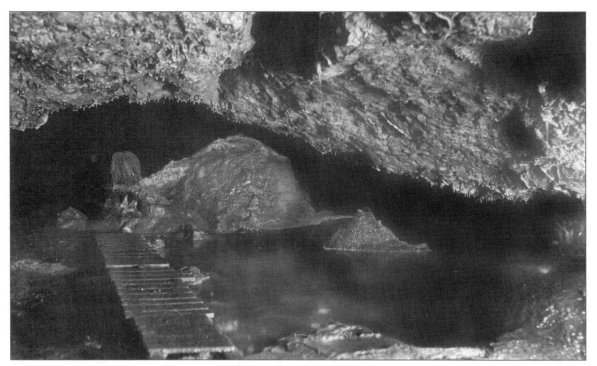

WOOKEY HOLE CAVES, *The Lake and the Island 1896* 38941

The caves were formed about 400 million years ago by the rainwater boring through the limestone. The underground streams and lakes, which swirled around to form caverns, finally emerge as the river Axe. Until 1948 divers had only been able to reach and explore Chamber 9. A tunnel was opened in 1975 to permit the public to visit previously inaccessible chambers, and modern divers have explored as far as Chamber 25. The caves contain the deepest sump in Britain at 67m.

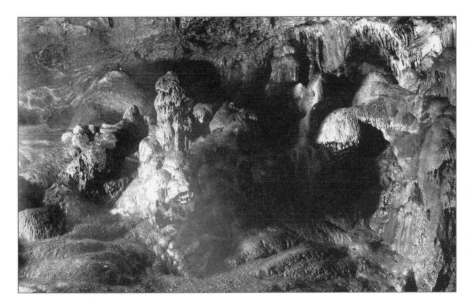

WOOKEY HOLE CAVES
The Witch 1896
38939

Legend says that a witch, exorcised by a monk from Glastonbury Abbey, turned to stone when he prayed and threw blessed water over her. In 1912 the complete skeleton of an old woman was found here, together with a dagger and a polished alabaster ball.

WOOKEY HOLE CAVES, *A Suspended Stone 1896* 38936

The temperature in the caves is a constant 11° Celsius - perfect for storing locally made Cheddar cheese (from Wyke Farms near Bruton), which has been stored here since February 2002. It is believed to be the only cave-matured Cheddar in the country.

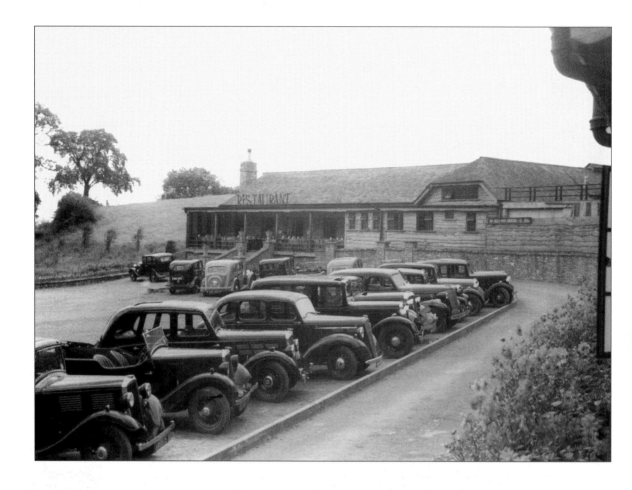

WOOKEY HOLE
The Car Park and the Restaurant c1950 W136307

This is in essence the same building today; it is now painted white and green, with bigger windows and no veranda, surrounded by the car park. The river Axe tumbles from the caves to feed a paper mill, built in 1848 using local stone. It was built by the same family who built the church, the school, Wookey Hole Club and many houses for their employees. The previous mill had been built by 1656. The paper produced here is still made by hand. The village flourishes on the tourist trade.

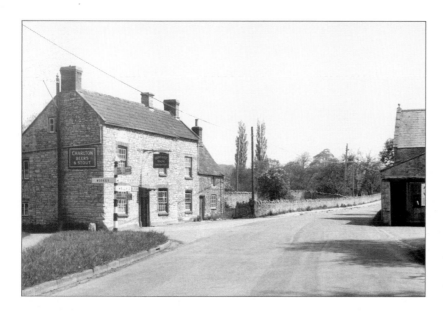

WOOKEY, *The Burcott Inn c1960* W136004

The name 'Wookey' probably comes from the Celtic 'wocob' or 'ocob', meaning 'cave'. The inn stands along the road to the village; the signpost (left) points to Wells, 2 miles away on the B3139 and to Wookey village. Before 1840 this was the site of two cottages used as the village school. The inn dates from the 19th century, and still has an old cider press, stables and paddock in the garden. Burcott Mill (right), a working water-powered mill, rebuilt in 1864, produces wholemeal flour. There has been a mill on this site for over 1000 years.

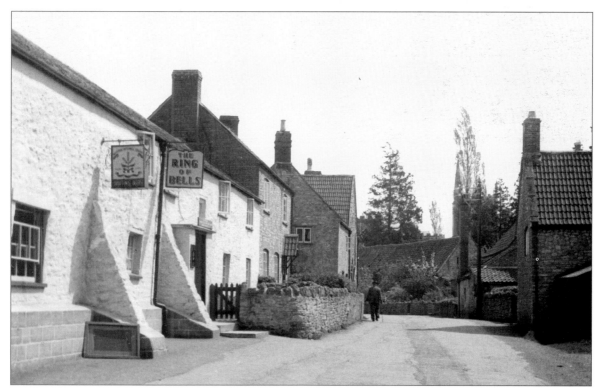

WOOKEY, *The Ring of Bells c1960* W136007

The land here was granted to old almshouses in Wells (the Bubwith, Stilles, and Wills almshouses) in 1441. In 1498 three cottages stood here. Part of the present building dates to the late 17th century.

BIBLIOGRAPHY

R D Reid: Wells Cathedral (The Friends of Wells Cathedral)

L S Colchester: Wells Cathedral

Tony Nott: History round Wells Issue 4: Poxe, Puncke and Puritane

R D Reid: Some Buildings of Somerset/Some Buildings of Mendip

Martin Langley and Edwina Small: Wells - An Historical Guide

Tony Scrase: Wells - A Pictorial History

J H Parker: Architectural Antiquities of the City of Wells

Thomas Serel: Historical Notes of the Church of St Cuthbert

Guidebook to the Parish Church of Wells, St Cuthbert's

F Neale and A Lovell: The Wells Cathedral Clock

Marion Meek: The Book of Wells

Wells Cathedral Stained Glass (Pitkin)

W I Stanton: The Ancient Springs, Streams and Underground Watercourses of the City of Wells

History Round Wells (Wells Local History Workshop)

R W Dunning: A History of Somerset

Penny Stokes: Mendip's Past

Kelly's Directory of Somerset

Phelp's History of Somerset

John Collinson: The History and Antiquities of Somerset

Michael Aston and Ian Burrow: The Archaeology of Somerset

The Somerset Village Book (Somerset Federation of Women's Institutes)

Keith Armstrong: The Story of Croscombe

Croscombe Parish Church booklet

Dinder Parish Church booklet

Hasler and Luker: The Parish of Wookey, a New History (Wookey Local History Group 1997)

Albert Thompson: The Book of Priddy

Lewis Carroll: Alice through the Looking Glass

ACKNOWLEDGEMENTS:

Anne Crawford, Wells Cathedral Archivist

Christopher Hawkes, Wells Museum

Kathy Scarisbrick, The Bishop's Palace, Henderson Rooms

Pat Robinson, Bishop's Palace Historian

Brian Luker, Wookey Local History Group

Staff at Wells and Shepton Mallet Public Libraries

The proprietor, the Rodney Stoke Inn

The proprietor, the Burcott Inn

The proprietor, Bucklegrove Caravan Park

Management and staff, Wookey Hole Caves and Restaurant

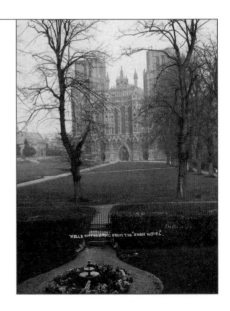

INDEX

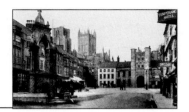

Frith Book Co Titles

www.francisfrith.co.uk

The Frith Book Company publishes over 100 new titles each year. A selection of those currently available are listed below. For latest catalogue please contact Frith Book Co.
Town Books 96 pages, approximately 100 photos. **County and Themed Books** 128 pages, approximately 150 photos (unless specified). All titles hardback with laminated case and jacket, except those indicated pb (paperback)

Amersham, Chesham & Rickmansworth (pb)	1-85937-340-2	£9.99	Devon (pb)	1-85937-297-x	£9.99
Andover (pb)	1-85937-292-9	£9.99	Devon Churches (pb)	1-85937-250-3	£9.99
Aylesbury (pb)	1-85937-227-9	£9.99	Dorchester (pb)	1-85937-307-0	£9.99
Barnstaple (pb)	1-85937-300-3	£9.99	Dorset (pb)	1-85937-269-4	£9.99
Basildon Living Memories (pb)	1-85937-515-4	£9.99	Dorset Coast (pb)	1-85937-299-6	£9.99
Bath (pb)	1-85937-419-0	£9.99	Dorset Living Memories (pb)	1-85937-584-7	£9.99
Bedford (pb)	1-85937-205-8	£9.99	Down the Severn (pb)	1-85937-560-x	£9.99
Bedfordshire Living Memories	1-85937-513-8	£14.99	Down The Thames (pb)	1-85937-278-3	£9.99
Belfast (pb)	1-85937-303-8	£9.99	Down the Trent	1-85937-311-9	£14.99
Berkshire (pb)	1-85937-191-4	£9.99	East Anglia (pb)	1-85937-265-1	£9.99
Berkshire Churches	1-85937-170-1	£17.99	East Grinstead (pb)	1-85937-138-8	£9.99
Berkshire Living Memories	1-85937-332-1	£14.99	East London	1-85937-080-2	£14.99
Black Country	1-85937-497-2	£12.99	East Sussex (pb)	1-85937-606-1	£9.99
Blackpool (pb)	1-85937-393-3	£9.99	Eastbourne (pb)	1-85937-399-2	£9.99
Bognor Regis (pb)	1-85937-431-x	£9.99	Edinburgh (pb)	1-85937-193-0	£8.99
Bournemouth (pb)	1-85937-545-6	£9.99	England In The 1880s	1-85937-331-3	£17.99
Bradford (pb)	1-85937-204-x	£9.99	Essex - Second Selection	1-85937-456-5	£14.99
Bridgend (pb)	1-85937-386-0	£7.99	Essex (pb)	1-85937-270-8	£9.99
Bridgwater (pb)	1-85937-305-4	£9.99	Essex Coast	1-85937-342-9	£14.99
Bridport (pb)	1-85937-327-5	£9.99	Essex Living Memories	1-85937-490-5	£14.99
Brighton (pb)	1-85937-192-2	£8.99	Exeter	1-85937-539-1	£9.99
Bristol (pb)	1-85937-264-3	£9.99	Exmoor (pb)	1-85937-608-8	£9.99
British Life A Century Ago (pb)	1-85937-213-9	£9.99	Falmouth (pb)	1-85937-594-4	£9.99
Buckinghamshire (pb)	1-85937-200-7	£9.99	Folkestone (pb)	1-85937-124-8	£9.99
Camberley (pb)	1-85937-222-8	£9.99	Frome (pb)	1-85937-317-8	£9.99
Cambridge (pb)	1-85937-422-0	£9.99	Glamorgan	1-85937-488-3	£14.99
Cambridgeshire (pb)	1-85937-420-4	£9.99	Glasgow (pb)	1-85937-190-6	£9.99
Cambridgeshire Villages	1-85937-523-5	£14.99	Glastonbury (pb)	1-85937-338-0	£7.99
Canals And Waterways (pb)	1-85937-291-0	£9.99	Gloucester (pb)	1-85937-232-5	£9.99
Canterbury Cathedral (pb)	1-85937-179-5	£9.99	Gloucestershire (pb)	1-85937-561-8	£9.99
Cardiff (pb)	1-85937-093-4	£9.99	Great Yarmouth (pb)	1-85937-426-3	£9.99
Carmarthenshire (pb)	1-85937-604-5	£9.99	Greater Manchester (pb)	1-85937-266-x	£9.99
Chelmsford (pb)	1-85937-310-0	£9.99	Guildford (pb)	1-85937-410-7	£9.99
Cheltenham (pb)	1-85937-095-0	£9.99	Hampshire (pb)	1-85937-279-1	£9.99
Cheshire (pb)	1-85937-271-6	£9.99	Harrogate (pb)	1-85937-423-9	£9.99
Chester (pb)	1-85937-382 8	£9.99	Hastings and Bexhill (pb)	1-85937-131-0	£9.99
Chesterfield (pb)	1-85937-378-x	£9.99	Heart of Lancashire (pb)	1-85937-197-3	£9.99
Chichester (pb)	1-85937-228-7	£9.99	Helston (pb)	1-85937-214-7	£9.99
Churches of East Cornwall (pb)	1-85937-249-x	£9.99	Hereford (pb)	1-85937-175-2	£9.99
Churches of Hampshire (pb)	1-85937-207-4	£9.99	Herefordshire (pb)	1-85937-567-7	£9.99
Cinque Ports & Two Ancient Towns	1-85937-492-1	£14.99	Herefordshire Living Memories	1-85937-514-6	£14.99
Colchester (pb)	1-85937-188-4	£8.99	Hertfordshire (pb)	1-85937-247-3	£9.99
Cornwall (pb)	1-85937-229-5	£9.99	Horsham (pb)	1-85937-432-8	£9.99
Cornwall Living Memories	1-85937-248-1	£14.99	Humberside (pb)	1-85937-605-3	£9.99
Cotswolds (pb)	1-85937-230-9	£9.99	Hythe, Romney Marsh, Ashford (pb)	1-85937-256-2	£9.99
Cotswolds Living Memories	1-85937-255-4	£14.99	Ipswich (pb)	1-85937-424-7	£9.99
County Durham (pb)	1-85937-398-4	£9.99	Isle of Man (pb)	1-85937-268-6	£9.99
Croydon Living Memories (pb)	1-85937-162-0	£9.99	Isle of Wight (pb)	1-85937-429-8	£9.99
Cumbria (pb)	1-85937-621-5	£9.99	Isle of Wight Living Memories	1-85937-304-6	£14.99
Derby (pb)	1-85937-367-4	£9.99	Kent (pb)	1-85937-189-2	£9.99
Derbyshire (pb)	1-85937-196-5	£9.99	Kent Living Memories(pb)	1-85937-401-8	£9.99
Derbyshire Living Memories	1-85937-330-5	£14.99	Kings Lynn (pb)	1-85937-334-8	£9.99

Available from your local bookshop or from the publisher

Frith Book Co Titles (continued)

Title	ISBN	Price	Title	ISBN	Price
Lake District (pb)	1-85937-275-9	£9.99	Sherborne (pb)	1-85937-301-1	£9.99
Lancashire Living Memories	1-85937-335-6	£14.99	Shrewsbury (pb)	1-85937-325-9	£9.99
Lancaster, Morecambe, Heysham (pb)	1-85937-233-3	£9.99	Shropshire (pb)	1-85937-326-7	£9.99
Leeds (pb)	1-85937-202-3	£9.99	Shropshire Living Memories	1-85937-643-6	£14.99
Leicester (pb)	1-85937-381-x	£9.99	Somerset	1-85937-153-1	£14.99
Leicestershire & Rutland Living Memories	1-85937-500-6	£12.99	South Devon Coast	1-85937-107-8	£14.99
Leicestershire (pb)	1-85937-185-x	£9.99	South Devon Living Memories (pb)	1-85937-609-6	£9.99
Lighthouses	1-85937-257-0	£9.99	South East London (pb)	1-85937-263-5	£9.99
Lincoln (pb)	1-85937-380-1	£9.99	South Somerset	1-85937-318-6	£14.99
Lincolnshire (pb)	1-85937-433-6	£9.99	South Wales	1-85937-519-7	£14.99
Liverpool and Merseyside (pb)	1-85937-234-1	£9.99	Southampton (pb)	1-85937-427-1	£9.99
London (pb)	1-85937-183-3	£9.99	Southend (pb)	1-85937-313-5	£9.99
London Living Memories	1-85937-454-9	£14.99	Southport (pb)	1-85937-425-5	£9.99
Ludlow (pb)	1-85937-176-0	£9.99	St Albans (pb)	1-85937-341-0	£9.99
Luton (pb)	1-85937-235-x	£9.99	St Ives (pb)	1-85937-415-8	£9.99
Maidenhead (pb)	1-85937-339-9	£9.99	Stafford Living Memories (pb)	1-85937-503-0	£9.99
Maidstone (pb)	1-85937-391-7	£9.99	Staffordshire (pb)	1-85937-308-9	£9.99
Manchester (pb)	1-85937-198-1	£9.99	Stourbridge (pb)	1-85937-530-8	£9.99
Marlborough (pb)	1-85937-336-4	£9.99	Stratford upon Avon (pb)	1-85937-388-7	£9.99
Middlesex	1-85937-158-2	£14.99	Suffolk (pb)	1-85937-221-x	£9.99
Monmouthshire	1-85937-532-4	£14.99	Suffolk Coast (pb)	1-85937-610-x	£9.99
New Forest (pb)	1-85937-390-9	£9.99	Surrey (pb)	1-85937-240-6	£9.99
Newark (pb)	1-85937-366-6	£9.99	Surrey Living Memories	1-85937-328-3	£14.99
Newport, Wales (pb)	1-85937-258-9	£9.99	Sussex (pb)	1-85937-184-1	£9.99
Newquay (pb)	1-85937-421-2	£9.99	Sutton (pb)	1-85937-337-2	£9.99
Norfolk (pb)	1-85937-195-7	£9.99	Swansea (pb)	1-85937-167-1	£9.99
Norfolk Broads	1-85937-486-7	£14.99	Taunton (pb)	1-85937-314-3	£9.99
Norfolk Living Memories (pb)	1-85937-402-6	£9.99	Tees Valley & Cleveland (pb)	1-85937-623-1	£9.99
North Buckinghamshire	1-85937-626-6	£14.99	Teignmouth (pb)	1-85937-370-4	£7.99
North Devon Living Memories	1-85937-261-9	£14.99	Thanet (pb)	1-85937-116-7	£9.99
North Hertfordshire	1-85937-547-2	£14.99	Tiverton (pb)	1-85937-178-7	£9.99
North London (pb)	1-85937-403-4	£9.99	Torbay (pb)	1-85937-597-9	£9.99
North Somerset	1-85937-302-x	£14.99	Truro (pb)	1-85937-598-7	£9.99
North Wales (pb)	1-85937-298-8	£9.99	Victorian & Edwardian Dorset	1-85937-254-6	£14.99
North Yorkshire (pb)	1-85937-236-8	£9.99	Victorian & Edwardian Kent (pb)	1-85937-624-X	£9.99
Northamptonshire Living Memories	1-85937-529-4	£14.99	Victorian & Edwardian Maritime Album (pb)	1-85937-622-3	£9.99
Northamptonshire	1-85937-150-7	£14.99	Victorian and Edwardian Sussex (pb)	1-85937-625-8	£9.99
Northumberland Tyne & Wear (pb)	1-85937-281-3	£9.99	Villages of Devon (pb)	1-85937-293-7	£9.99
Northumberland	1-85937-522-7	£14.99	Villages of Kent (pb)	1-85937-294-5	£9.99
Norwich (pb)	1-85937-194-9	£8.99	Villages of Sussex (pb)	1-85937-295-3	£9.99
Nottingham (pb)	1-85937-324-0	£9.99	Warrington (pb)	1-85937-507-3	£9.99
Nottinghamshire (pb)	1-85937-187-6	£9.99	Warwick (pb)	1-85937-518-9	£9.99
Oxford (pb)	1-85937-411-5	£9.99	Warwickshire (pb)	1-85937-203-1	£9.99
Oxfordshire (pb)	1-85937-430-1	£9.99	Welsh Castles (pb)	1-85937-322-4	£9.99
Oxfordshire Living Memories	1-85937-525-1	£14.99	West Midlands (pb)	1-85937-289-9	£9.99
Paignton (pb)	1-85937-374-7	£7.99	West Sussex (pb)	1-85937-607-x	£9.99
Peak District (pb)	1-85937-280-5	£9.99	West Yorkshire (pb)	1-85937-201-5	£9.99
Pembrokeshire	1-85937-262-7	£14.99	Weston Super Mare (pb)	1-85937-306-2	£9.99
Penzance (pb)	1-85937-595-2	£9.99	Weymouth (pb)	1-85937-209-0	£9.99
Peterborough (pb)	1-85937-219-8	£9.99	Wiltshire (pb)	1-85937-277-5	£9.99
Picturesque Harbours	1-85937-208-2	£14.99	Wiltshire Churches (pb)	1-85937-171-x	£9.99
Piers	1-85937-237-6	£17.99	Wiltshire Living Memories (pb)	1-85937-396-8	£9.99
Plymouth (pb)	1-85937-389-5	£9.99	Winchester (pb)	1-85937-428-x	£9.99
Poole & Sandbanks (pb)	1-85937-251-1	£9.99	Windsor (pb)	1-85937-333-x	£9.99
Preston (pb)	1-85937-212-0	£9.99	Wokingham & Bracknell (pb)	1-85937-329-1	£9.99
Reading (pb)	1-85937-238-4	£9.99	Woodbridge (pb)	1-85937-498-0	£9.99
Redhill to Reigate (pb)	1-85937-596-0	£9.99	Worcester (pb)	1-85937-165-5	£9.99
Ringwood (pb)	1-85937-384-4	£7.99	Worcestershire Living Memories	1-85937-489-1	£14.99
Romford (pb)	1-85937-319-4	£9.99	Worcestershire	1-85937-152-3	£14.99
Royal Tunbridge Wells (pb)	1-85937-504-9	£9.99	York (pb)	1-85937-199-x	£9.99
Salisbury (pb)	1-85937-239-2	£9.99	Yorkshire (pb)	1-85937-186-8	£9.99
Scarborough (pb)	1-85937-379-8	£9.99	Yorkshire Coastal Memories	1-85937-506-5	£14.99
Sevenoaks and Tonbridge (pb)	1-85937-392-5	£9.99	Yorkshire Dales	1-85937-502-2	£14.99
Sheffield & South Yorks (pb)	1-85937-267-8	£9.99	Yorkshire Living Memories (pb)	1-85937-397-6	£9.99

See Frith books on the internet at www.francisfrith.co.uk

FRITH PRODUCTS & SERVICES

Francis Frith would doubtless be pleased to know that the pioneering publishing venture he started in 1860 still continues today. Over a hundred and forty years later, The Francis Frith Collection continues in the same innovative tradition and is now one of the foremost publishers of vintage photographs in the world. Some of the current activities include:

Interior Decoration

Today Frith's photographs can be seen framed and as giant wall murals in thousands of pubs, restaurants, hotels, banks, retail stores and other public buildings throughout the country. In every case they enhance the unique local atmosphere of the places they depict and provide reminders of gentler days in an increasingly busy and frenetic world.

Product Promotions

Frith products are used by many major companies to promote the sales of their own products or to reinforce their own history and heritage. Frith promotions have been used by Hovis bread, Courage beers, Scots Porage Oats, Colman's mustard, Cadbury's foods, Mellow Birds coffee, Dunhill pipe tobacco, Guinness, and Bulmer's Cider.

Genealogy and Family History

As the interest in family history and roots grows world-wide, more and more people are turning to Frith's photographs of Great Britain for images of the towns, villages and streets where their ancestors lived; and, of course, photographs of the churches and chapels where their ancestors were christened, married and buried are an essential part of every genealogy tree and family album.

Frith Products

All Frith photographs are available Framed or just as Mounted Prints and Posters (size 23 x 16 inches). These may be ordered from the address below. From time to time other products - Address Books, Calendars, Table Mats, etc - are available.

The Internet

Already fifty thousand Frith photographs can be viewed and purchased on the internet through the Frith websites and a myriad of partner sites.

For more detailed information on Frith companies and products, look at these sites:

www.francisfrith.co.uk
www.francisfrith.com
(for North American visitors)

See the complete list of Frith Books at:

www.francisfrith.co.uk

This web site is regularly updated with the latest list of publications from the Frith Book Company. If you wish to buy books relating to another part of the country that your local bookshop does not stock, you may purchase on-line.

For further information, trade, or author enquiries please contact us at the address below:
The Francis Frith Collection, Frith's Barn, Teffont, Salisbury, Wiltshire, England SP3 5QP.
Tel: +44 (0)1722 716 376 Fax: +44 (0)1722 716 881 Email: sales@francisfrith.co.uk

See Frith books on the internet at www.francisfrith.co.uk

HOW TO ORDER YOUR FREE MOUNTED PRINT
and other Frith prints at half price

Mounted Print
Overall size 14 x 11 inches

*Fill in and cut out this voucher and return it
with your remittance for £2.25 (to cover
postage and handling to UK addresses).
For overseas addresses please include £4.00
post and handling.
Choose any photograph included in this book.
Your SEPIA print will be A4 in size. It will be
mounted in a cream mount with a burgundy
rule line (overall size 14 x 11 inches).*

Order additional Mounted Prints
at HALF PRICE (only £7.49 each*)

If you would like to order more Frith prints
from this book, possibly as gifts for friends
and family, you can buy them at half price
(with no additional postage and handling
costs).

Have your Mounted Prints framed

For an extra £14.95 per print* you can have
your mounted print(s) framed in an elegant
polished wood and gilt moulding, overall
size 16 x 13 inches (no additional postage
and handling required).

*** IMPORTANT!**

**These special prices are only available if you
order at the same time as you order your free
mounted print. You must use the ORIGINAL
VOUCHER on this page (no copies permitted).
We can only despatch to one address.**

Voucher for *FREE* and Reduced Price Frith Prints

*Please do not photocopy this voucher. Only the original is valid,
so please fill it in, cut it out and return it to us with your order.*

Picture ref no	Page number	Qty	Mounted @ £7.49	Framed + £14.95	Total Cost
		1	Free of charge*	£	£
			£7.49	£	£
			£7.49	£	£
			£7.49	£	£
			£7.49	£	£
Please allow 28 days for delivery			£7.49	£	£
			* Post & handling (UK)		£2.25
			Total Order Cost		£

Title of this book .

I enclose a cheque/postal order for £
made payable to 'The Francis Frith Collection'

OR please debit my Mastercard / Visa / Switch / Amex card
(credit cards please on all overseas orders), details below

Card Number

Issue No (Switch only) Valid from (Amex/Switch)

Expires Signature

Name Mr/Mrs/Ms .
Address .
. .
. .
. Postcode
Daytime Tel No .
Email .

Valid to 31/12/05

Send completed Voucher form to:
The Francis Frith Collection, Frith's Barn, Teffont, Salisbury, Wiltshire SP3 5QP

Free Print – see overleaf

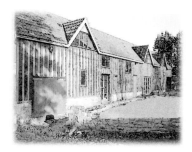

Would you like to find out more about Francis Frith?

We have recently recruited some entertaining speakers who are happy to visit local groups, clubs and societies to give an illustrated talk documenting Frith's travels and photographs. If you are a member of such a group and are interested in hosting a presentation, we would love to hear from you.

Our speakers bring with them a small selection of our local town and county books, together with sample prints. They are happy to take orders. A small proportion of the order value is donated to the group who have hosted the presentation. The talks are therefore an excellent way of fundraising for small groups and societies.

Can you help us with information about any of the Frith photographs in this book?

We are gradually compiling an historical record for each of the photographs in the Frith archive. It is always fascinating to find out the names of the people shown in the pictures, as well as insights into the shops, buildings and other features depicted.

If you recognize anyone in the photographs in this book, or if you have information not already included in the author's caption, do let us know. We would love to hear from you, and will try to publish it in future books or articles.

Our production team

Frith books are produced by a small dedicated team at offices in the converted Grade II listed 18th-century barn at Teffont near Salisbury, illustrated above. Most have worked with the Frith Collection for many years. All have in common one quality: they have a passion for the Frith Collection. The team is constantly expanding, but currently includes:

Jason Buck, John Buck, Douglas Mitchell-Burns, Ruth Butler, Heather Crisp, Isobel Hall, Maureen Harrison, Julian Hight, Peter Horne, James Kinnear, Karen Kinnear, Tina Leary, David Marsh, Sue Molloy, Kate Rotondetto, Dean Scource, Eliza Sackett, Terence Sackett, Sandra Sampson, Adrian Sanders, Sandra Sanger, Julia Skinner, Lewis Taylor, Shelley Tolcher, and Lorraine Tuck.